Ways to See Great Britain

Also by Alice Stevenson
Ways to Walk in London

WAYS TO SEE GREAT BRITAIN

Curious Places & Surprising Perspectives

Text and illustrations by Alice Stevenson

1 3 5 7 9 10 8 6 4 2

First published in 2017 by September Publishing

Text and illustration © Alice Stevenson 2017

The right of Alice Stevenson to be identified as the author
of this work has been asserted by her in accordance with the
Copyright Designs and Patents Act 1988.

Printed in Poland on paper from responsibly managed,
sustainable sources by Hussar Books.

ISBN 978-1-910463-48-2

September Publishing
www.septemberpublishing.org

In memory of Caroline Cawston

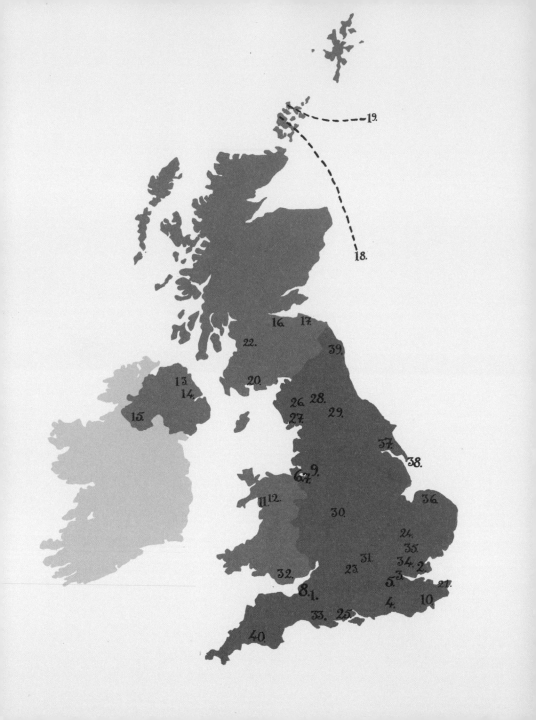

CONTENTS

The inspiration to write this book came from an increasing need to discover my home nation. Growing up and living in London, I have always been aware of how little of my country I actually know; so much of my life has played out in this one densely populated, international little pocket of south-east England.

I set out in a spirit of openness, to find ways to experience destinations meaningfully: to discover points of interest or connection to a place, whether it be a remote island or an industrial suburb. As an artist and illustrator, the visual tends to be my 'way in'. A detail catches my eye – the texture of a drystone wall, the strange patterns of switched-off neon signs in the daytime or decorative, Art Deco tiles in the doorways of unassuming terraces – and it leads to the discovery of the wealth of tales and layers of history which lie beneath the surface.

As in my previous book, *Ways to Walk in London*, I set myself the challenge of drawing and painting patterns and abstract reinterpretations of what I'd seen, seeking to capture the essence of a space as opposed to just recreating its surface, figuratively. Of course, it is not just the place itself that creates an atmosphere; the weather, our mood, the people we meet all have an impact on a sightseeing experience.

I was exploring Britain in a year when the divide between London and the rest of the country seemed more pronounced than ever. It appeared that both the build-up to and aftermath of the UK referendum on the EU created great social and political divisions, alienating different groups – even families – from each other, and exposing ungenerous and limiting attitudes. But that is not what I saw on my travels: I found a varied land, contradictory and complex in culture, geography, history and ecology. This was deeply heartening.

This book also became an exploration of the pastime of travel. While it can be stimulating and thought-provoking,

I nonetheless could find it bewildering or disappointing when the reality of being somewhere was less rewarding than my preconceived ideas.

My destinations came about in a variety of ways. Some were places I had long intended to visit: these were the journeys that became, in part, an exercise in managing expectations; of reconciling how the city or area existed in my mind with the reality of being there.

I also chose places that are frequently missed in favour of their more celebrated neighbours. I followed recommendations from friends, and found points of interest on one trip that motivated me to travel to an entirely different corner of the country – I loved creating these unexpected links. For example, visiting the Liverpool Metropolitan Cathedral introduced me to architect Frederick Gibberd, which prompted me to visit the New Town of Harlow, over 200 miles south-east.

I went to remote, rural locales and busy urban centres; spent time indoors and outside. I discovered places rich in contrast, and others that were impossible to neatly categorise.

As a walker and non-driver, I travel in a slow and roundabout way; my choices were limited by what I could reach on foot or public transport, or where a willing friend would chauffeur me. Planning my trips became as much a part of the creative process as the journeys themselves, yet a network of locales unfolded exponentially over the course of the year.

Many of my excursions involved walking, as I still find being on foot the most conducive way of connecting to a place, but I also saw Great Britain from train windows, inside regional art galleries and pubs, and on boats and local buses.

So this is not (just) a travel guide. It is a book about how to observe the detail and truly experience being in a place. Its aim is to inspire you to be curious, to take your time and really look. To see the rich diversity that makes up our land, and perhaps to get out your notebook and reinterpret it for yourself.

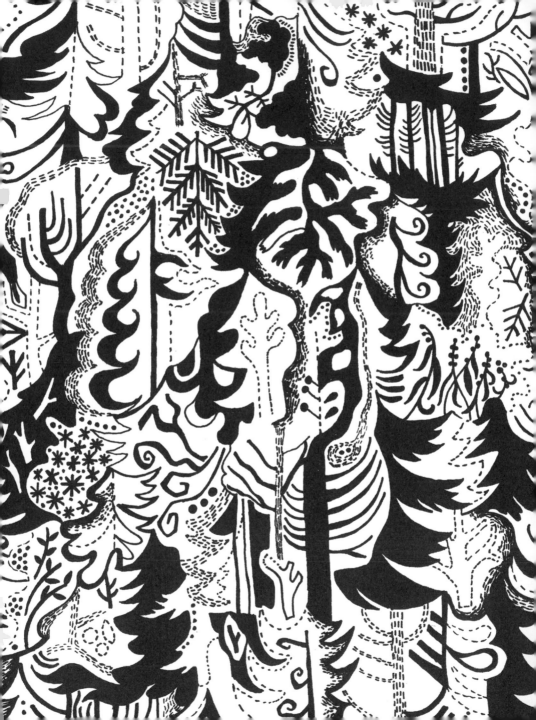

STOURHEAD

Woodland to Parkland

I had hoped for crisp autumn sunlight today, but it is misty and damp in Great Bradley Wood. Most of our immediate surroundings are distorted in the fog, apart from a carpet of orange leaves with moss-covered branches randomly arranged underfoot, as if thrown to divine the future. Islands of star moss appear, and single lines of ivy wind up the trunk of an alder like decorative embroidery.

The mist makes the world ten metres away become indistinct, then entirely erased, creating a geographical disconnection to our surroundings. We are in a small woodland bubble floating through a white void. The trees to our right clear, revealing what should be a dramatic view towards Wiltshire and King Alfred's Tower, but instead the fern-covered floor just stops, revealing only faint grey shadows of the pines on the downwards slope. A single branch in the shape of a sinister dinosaur bird materialises from the edge of the flat land.

These ancient woods, part of the Maiden Bradley Estate, are a Site of Special Scientific Interest. Looking inwards, the spaces between the skinny young ash are grey and smoky, as

if there is a fire in the forest. The distant trees are blurred together as if rendered in grey-green ink on wet paper or smudgy chalk pastel. This gives the trees that are closer an ultra-distinct quality, like they've been painted on the blurry backdrop with thick black ink. The graphic shapes of this scene, emerging from the mist, bring to mind a painted stage set.

We discover an abandoned book to the side of a path. This atmosphere of fairy-tale foreboding cannot help but make random things feel significant. We pass a group of dying foxgloves, loitering like a gang of delinquent youths. As we near the gate we find a hydrangea bush. The tips of its shiny green leaves are a deep red, as if they've been dipped in blood. The petals of its flowers vary from pale ice blue to deep pink and purple, as if they have been tie-dyed or the rain has caused their colours to bleed.

On the road now we walk towards a tunnel of beech, the world melting away to blankness around it. The trees join to create a broad arch and at the end of the tunnel the indistinctiveness merges the branches of the two trees together, brushstrokes of yellow and green with dark marks in a curved formation, an illusion which dissipates as we walk through it.

In the grounds of Stourhead, the view across the artificial lake is a perfect arrangement of tall Italian alder and western hemlock trees in a striking blend of brilliant red to muted green. In spite of the mist, their edges burn with vitality. The elegantly angular gingko tree is surrounded by a deep golden halo of leaves. In the wooded area, leading to the grotto, we look out through a mesh of delightfully arranged and coloured foliage.

This composed arranged scene is the vision of Henry Hoare II and was laid out between 1741 and 1780 in a classical eighteenth-century design that is archetypal of the landscape movement. It is beguiling here, but knowing that this atmosphere is entirely contrived takes the edge off the enchantment, especially after experiencing the way that the mist in Great Bradley Wood transformed our surroundings into a painted, fairy-tale stage set.

SOUTHEND-ON-SEA

Neon and Nothingness

Something glinting catches my eye. I go closer and it is a spider's web the tiny strands gently sparkling as I stare deeper into its hypnotic centre.

We leave the platform and head to the High Street. It's a pedestrian shopping street, a combination of 1960s' blocks and Victorian buildings which house the ubiquitous chains found in any town centre alongside pawn and discount gold shops. It is 1 November, and the Christmas lights are up on the street lamps. Spiky metal stars orbit one-dimensional Christmas trees, their edges lumpy with tiny lights. It is so foggy that it seems as if a sort of blankness is following us. Heading towards Royal Terrace, I begin to make out tangled shapes of the Adventure Island amusement park through the thick cloud.

Southend rapidly developed as a seaside resort in the Victorian era and became a popular holiday and day trip destination for Londoners. Ross's father remembers it as a great day out during his post-war east London childhood. However, the increased affordability of overseas holidays in the latter part of the twentieth century saw Southend's fall from favour into rather seedy disrepute. This Sunday, it strikes me as thriving in a scrappy sort of way.

We decide to walk a little along Marine Parade, Adventure Island on our right. The yellow roller coaster

15

loops and winds and strange flower-like metallic eruptions suggestive of palm trees emerge up the slope of the ride. On our left we pass arcades which are open but fairly empty. Ross reminisces about coming to Southend on a Saturday as a teenager to hit the arcades, a two-litre bottle of White Lightning in his backpack. We get our fortune told by the creepy animatronic fortune teller and he tells us we will prosper, of course. We come to Neptunes, a fish and chip restaurant housed in an early twentieth-century building. Its surface is adorned by the skeleton of a neon sign – switched off in daylight, it is a wondrous display of dolphins leaping out of curly waves and seagulls gliding under puffy clouds, all rendered in white metal wire against the white paint of the house, at once subtle, drab and delicate.

A similar phenomenon occurs a couple of doors down at the Las Vegas Grill. Yellow-and-grey wires emerge from the green shop sign, forming a semi-Ferris-wheel shape, coming up like a rising sun. I imagine it glowing invitingly at night time. The bubble letters of the 'Las Vegas Grill' sign are scored within by a slightly lighter yellow line. It's as if in daylight we can see under the skin of the spectacle; it somehow makes it all vulnerable and strange.

A little further along we reach Bobby's of Southend Fish & Chips Burger Bar. Above the signage, faded photos of ice cream cones fan out in a semicircle. My eyes move upwards and, to my delight, I realise the turret on the corner of the building is fashioned in the style of an upside-down ice cream

cone, the wafer's texture perfectly rendered in plaster and painted yellow.

We turn back on ourselves to walk towards Southend Pier, the largest pleasure pier in the world, and, as we approach, most of its 1.34-mile length is shrouded in chilly fog. We pass a lonely looking slide sitting in the sand and, out at sea, pale figures stand in canoes. We climb up the steps, passing through the visitors centre, and begin our walk outwards into nothing.

On the creaking boards, the mist seems to wrap around everything and muffle sounds. The whooshing and yelps of joy from the amusement park are ghostly and disproportionately quiet, intermingled with beeps and foghorns of distant boats. I can see up to about ten metres in front of me before the pier is enveloped by nothingness and, each time I look back, the complex structures of Adventure Island are more faded until there is only white emptiness behind me. Ross strides ahead and I irrationally panic that he is disappearing.

We stop and lean over the railings after about half a mile and can see nothing in front of us. We laugh that we are literally gazing into the void, but it feels odd and disconcerting, as if we are officially nowhere. I recall one of my favourite childhood films, *The NeverEnding Story*, where the hero is on a quest to stop 'The Big Nothing', which is destroying the world of the imagination. I think about how seaside towns like Southend exist as an idea in our country's consciousness and how that shifts and alters over time. This place is the height of glamour and excitement to a child, but to a knowing adult it is shabby and kitsch.

We walk all the way to the end of the pier in this perpetual state of nowhere and then we get the railway back, trundling through the blankness in reverse. Back at the start of the pier we step down bright blue painted steps, surveying the strange kingdom of Adventure Island, which seems reassuring and normal

17

after our walk on the pier. The roller coaster tracks look like a ribbon flowing in the wind that has been frozen in time. An exaggerated cartoon-style cottage emerges from the muddle of rides, its extreme, slanting angles have a nightmarish quality.

We make our way back onto the main road that runs parallel to the sea, making our way eastwards. A row of palm trees lines the road: the universal symbol of holidays and escape. The fog renders them silhouettes, fading gradually into the distance. We follow them eastwards and onwards, past the grey beach and endless Victorian villas, to the reassuringly working-harbour environment of Leigh-on-Sea for fish and chips in a pub by a fire.

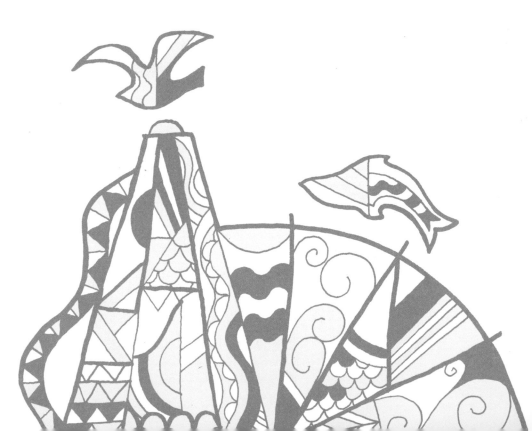

ERITH

Esoteric Estuary

If you head to the gardens – down Stonewood Road from Erith train station – you reach the last stretch of the Thames before Greater London officially ends.

Riverside Gardens is a wide space surrounded by low walls. It is dominated by a large flower bed, which is surprisingly empty considering it is midsummer, in the shape of hexagons merged together. Before you reach the river there are tall perennial shrubs and palm trees, and peeping over the top of them is the strange landscape of the north bank of the Thames: gently undulating yellow-and-brown hills with a few industrial buildings on its banks. This desolate view, combined with the weird shape of the beds, feels like we are in a dystopia dreamed up in the early 1980s. In the middle of the flower bed is a flagpole with a small plaque seemingly commemorating the First World War; someone has written on it in marker pen, 'Peace in 2014'. Little do we know this is just the first of many mysterious markings that will litter this journey.

Erith existed as a fishing port until the mid-nineteenth century, where it briefly enjoyed status as a riverside resort. The area became increasingly industrialised in the twentieth century and was heavily bombed in the Blitz, leaving it vulnerable to experiments in post-war town planning. We walk up the High Street, past Georgian cottages and late-twentieth-century municipal buildings. The side of the boarded-up Cross Keys pub (closed in 2010 after a

group of travellers rode five horses into the bar) strikes an imposing silhouette against the glaring midday sun. The High Street is deserted. My eyes are caught by musical notes drawn on the window of the Playhouse, and Roger notices the fading lettering of a sign for joinery and plastering. It's not a place you'd describe as thriving; it feels as though the town is covered in a sticky layer of dust.

Meeting the river again, we investigate Erith Pier, the longest in London. It's wide and empty, ringed with bright blue railings; we follow it round its right-angle bend, an odd feature for a pier but one we accept unquestioningly, in the context of the bizarre environment. Only a hut at the end remains, which contains the measuring and telemetry equipment. On the side is a small metal plaque stating:

Frankie
You are missed by all of us
You was my rock
28/11/90–20/2/11

Such a small but heartfelt commemoration on this large pier adds to the incongruity of this landscape. This tribute seems so tiny in the vast and empty place, it's as if proportion and scale are distorted here as we look out over the grey water to the sweeping edge of the city, dotted with enigmatic functional buildings.

Back on the river path I become mesmerised by the waves of the mud flats, winding lines that wave and loop around each other, weaving against the rhythmical ridges of wet sand. It is as if we are looking out across a detailed map of this indefinable place, but without markers or any sense of which way to turn. Roger's keen photographer's eye spots crude, chalked insects rendered on the footpath, spirals and ovals with multiple legs protruding from them. No explanation of this temporary graffiti is offered, but they feel important – like clues on our suburban quest, if only we could understand what they mean.

The river path ends after a while, sending us to James Watt Way and up to Manor Road, where we walk along a road flanked by an industrial estate, fenced by metal gates and wire mesh; scrubby weeds force themselves up through the ground to wind around these metallic borders,

plastic bags caught in brambles. After half a mile, a narrow tarmac path takes us back towards the river, passing Erith Yacht Club, a large square building perched beside the muddy water's edge, surrounded by moored vessels. The idea of a yacht club here pleases me, as I tend to think of them belonging in wealthy holiday destinations. I imagine suntanned millionaires sipping cocktails watching the sun set over Rainham Marshes.

We follow the path out onto Crayford Marshes, away from the town, walking towards the mouth of the River Darent. This is one of the few remaining areas of Thames grazing marsh in London, supporting a wealth of wildlife. But on this hot July day, the sun has scorched the reeds and long grasses, and the cow parsley looks dehydrated. There is nothing pretty or quaint about our surroundings, yet the bleached openness, the small sailing boats scattered across the grey water and the line of deep red gorse dividing the grasses from the reeds give it an elegance that is enhanced by its oddness.

To our left we follow a wild and spiky hedge full of brambles and sweet peas before coming to a dust path, which leads out to scrubby common land where a handful of horses graze peacefully. It's incredibly quiet as the path rises, enabling us to see for miles over the flat land to the grey shapes of warehouses and pylons in the distance. Looking over the edge we notice a burnt-out car on the dusty road. It feels like we are walking through the setting of a violent thriller in the aftermath of an unsavoury showdown.

There is a concrete enclosure with a small gap in one of its four walls. It sits surrounded for hundreds of metres by flat dry grass but it appears to be full of foliage; tree tops emerge from the top of it. We speculate rather fruitlessly as to its purpose.

Walking by another industrial estate, we peer down. It's a maze of warehouses and cranes; geometric metal shapes and barbed wire, all deeply purposeful but entirely unknowable to me, forming an abstract pattern in the afternoon sun. Heaps of tyres and gas tankers pile up in skips. My sense of scale momentarily shifts, and I imagine I am looking into boxes of screws, bolts and tools on a workbench.

The path wraps around the corner on to the River Darent: a Kentish tributary of the Thames. Today, there is just a dry little stream at the bottom of a cracked clay bed. The Dartford Creek Barrier looms menacingly in front of us like part of a brutalist walkway on wooden stilts. Roger spots a weather-beaten wooden structure among the dry grass. Four round wooden plates are joined by beams in a T-shape, about a metre in length. On the surface of two of the wooden circles are faint images of a dragonfly and a ladybird. This must be some sort of community art project that has fallen into neglect, but we feel as though we have found fossils.

We come across a rusted information board covered in silver aerosol tags. It gleams and almost shimmers in the sunshine, perfectly embodying my experience of this walk. I feel visually illiterate, observing the world around me as if reading in a language I don't understand.

SHOREHAM-BY-SEA

Houseboats and Prayer Cushions

Behind the scattered, pale graves, sits a large, lumpy stone mound surrounded by an iron fence. It is similar in shape and angle to a dead tree trunk; one of its sides slopes into the ground as if to roots. It is the ruined nave of the original Norman St Mary de Haura church in Shoreham-by-Sea.

The main building of the church has been gradually developed over its 900-year life; it stands calmly in the sunshine, its dignified facade textured with flint. Peter and I walk inside the cool, pale interior and my eyes immediately fall on the bold compositions of the prayer cushions. English country scenes are rendered with modernist simplicity in bright primary colours. On one, I initially mistake a row of angels for beach huts. Another cushion features a winter scene with a subtler colour scheme: grey and pale blue on white, with perennial trees rendered in muted greens and browns. This cool palette is offset sharply against bright red rooftops. Ambitious attempts at texture and detail have been made; grey

shadows on the snow and bark on the trees. Within the limited needlepoint structure of squares of wool, these details become distorted and strange. A figure in red and a dog stand in the snow like characters from a 1980s' video game.

These simpler renditions of the landscape are reflected in our view as we wind up towards Upper Shoreham Road, through respectable streets of early twentieth-century suburban houses. The occasional flint garden wall echoes the nearly millennial site we've just been standing on. The soft slope of the South Downs begins to emerge above the triangular rooftops and chimneys. Something about the sight of the Downs always triggers a pang of melancholic nostalgia in my stomach – for childhood visits to my grandparents in Amberley, and escaping Brighton for walks and picnics as an art student. Soft treetops cover the hills, cloudlike clumps in varying hazy shades of green. They cluster around the spiky structure of Lancing College. I imagine reaching out to touch it and my fingers being pricked by its spires.

We make our way down to the bank of the River Adur, which flows out to the sea. On the other side, the green Down blanket meets the white Art Deco buildings of Brighton City Airport; small planes buzz around like insects and hundreds of pink valerians cluster below our feet.

Peter is taking me to see the houseboats that reside on the shingle spit that branches out from the west of the River Adur; a row of 40, no-longer-seaworthy torpedo boats and oyster catchers that have been converted to homes over the past 30 or so years. Appropriately, as we near the harbour front, a group of primary school girls bearing clipboards asks us to take part in a questionnaire about Shoreham, and in particular the houseboats and their value to the community. Across the water, the ramshackle boat dwellings sit on the mudflats as we answer their earnest questions. We say goodbye to the girls and a shadow of concern descends upon us. We wonder if the houseboat community is in danger of removal at the hands of property developers, as is the common fate of so

much that makes the UK interesting and varied. We follow Old Shoreham Road, veering away from the water's edge into the pleasantly bustling harbour front.

To our left, I notice a building shaped like a child's drawing of a house, with dark and light, stone chessboard squares and little arched doors and windows. It was known as Marlipins, and is thought to date back to the twelfth century and be the oldest secular building in Sussex; today it is the Marlipins Museum. I am struck by the historical and visual richness of this suburban seaside town that I never bothered to visit in the whole three years that I lived in Brighton.

Owing to the footbridge being closed for repairs, we end up taking a rather roundabout route via shuttle bus to our destination on the opposite side of the bank. We whizz past the angular walls and sculpted green mounds of the Old Shoreham Fort at the far tip of the spit. I am surprised to learn this was home to a thriving film studio in the early twentieth century, leading to the locality being known as 'Hollywood on Sea'. Knowledge of this past glamour injects the atmosphere of the place with a gentle poignancy.

We dismount and walk westerly along the towpath, looking out across the mudflats to Shoreham Harbour. The houseboats begin on our right. Some are particularly striking: *Verda* has large petal-shaped windows at its front and an old bus somehow absorbed into its body like a terrifying robot insect. While the houseboats themselves are fascinating in their individuality and ingenuity, what is most striking to me is all the 'stuff' surrounding them. Every deck that connects the boat with the towpath seems to house about a hundred items: watering cans, boots, bathtubs, endless piles of timber, piping, tanks, tools, flower pots, trays of seedlings, washing lines and bicycle wheels. On the other side of the towpath is a metre or so drop, reachable by wooden steps. This lower realm houses allotment-style gardens featuring much of the same accoutrements as the boat decks, with additions of chicken coups and bathtubs full of lavender and heaps of firewood.

Yet it doesn't feel chaotic, everything seems to have its own purpose and a sense of logic that I don't understand but instinctively respect. There are very few people around and an old wooden information board stands by the towpath, bleached by the sun and salt. Under the glass, a few black-and-white photographs of a boat at sea are randomly arranged on bright yellow paper. Beyond the allotment gardens, the backs of bungalows and clapboard houses are only metres away but seem to belong to a different planet. We pass under an abundant arch of elder and ahead of us is an estate agent's sign sticking out of a houseboat. This symbol of the conventional property world jars in these surroundings.

As we pass the last boat, I think back to the ruined nave of St Mary de Haura and the brightly coloured, pixelated scenes depicted on its prayer cushions, and I marvel at how many different worlds past, present and imagined I have glimpsed within just a couple of square miles.

LOWER MORDEN LANE

Christmas Street

Hillcross Avenue, the road that runs parallel to Morden Park, could be the most ordinary street in Britain. Elinor and I march along stoically through the drizzle, past the 1920s' semis, heading towards our destination at the bottom end of the park. Lower Morden Lane is renowned for an extravagant display of Christmas lights that causes traffic chaos as drivers slow down to admire the show. Joe, a friend who grew up nearby, called it 'Christmas Street' as a child, enthralled by this spectacle.

There is something soothing about the dullness of this suburban street. Its crazy-paved driveways are lit up in a dirty yellow street lamp glow, and the lack of people feels like a refreshing relief from the madness that overtakes London at this time of year. As we walk, Elinor talks to me of her relationship troubles, which are magnified and exacerbated by the technicolour hysteria of the season. There is something about the relentless imagery of societally prescribed happiness that throws your disappointments, failures and worries into remorselessly sharp relief, escalating anxieties to fever pitch. While my personal life is reasonably uneventful at the moment, I am exhausted and run-down, and as we walk these soggy streets we are united in a desire to run as far away from the festivities as possible, to take our troubles somewhere quiet and curl up on a carpet of pine needles, and let our winter melancholy and fears just be.

Still on Hillcross Avenue, lights start to appear, infrequent at first, but slowly increasing in numbers. We pass a house projecting moving disco lights over its surface, the front garden's ornamental pond reflecting a blurry version creating a bubbling cauldron. Another house has what appears to be a Star of David formed out of a tube of LED lights perched upon a

shrub. We speculate whether this is the result of ignorance or if a Jewish family are joining in the fun. Another house, painted white, with a large, black, empty driveway, has white netted lights dangling from the roof and white lights in the perfect bay trees by its entrance. A white tree, covered in white lights, shines through from the minimalist living room.

But these delights are merely a teaser for what awaits us over the roundabout in Lower Morden Lane, where it seems every home has gone to a tremendous amount of effort. Houses are covered in strips of LED lights forming complex, moving shapes. Patterns and cross formations move over their fronts, which to me suggest the Tudor architecture these buildings were inspired by. On our left, a giant inflatable Father Christmas, his sleigh led by a rather deflated reindeer, emerges from the side passage; an inflatable snowman and *Nutcracker* prince bring up the rear. A sign in the front garden, next to its charity collection bucket, clearly states how far we may walk into their driveway so we can peer more closely at these lumpen figures. As I gaze into their faces I feel an ugly sadness. It's as if we are looking straight into the heart of the emptiness of Christmas. However, the quietness of the area – Elinor, me and an after-school youth group are the only ones around – makes me feel that perhaps we are confronting our seasonal demons head on, on our own terms.

We pass several houses where lit-up shapes are stamped evenly over their facades: candles, *Nutcracker* princes, Santa,

Santa in a helicopter (yes, really!) dot walls like fresh tattoos. We pass clusters of deer on lawns, hollow constructions made with light-covered wire. It's like being in a world of neon skeletons or looking at the world through an X-ray screen. We walk past an artfully placed model of Santa climbing into a window, his outline created by a string of lights. The strangeness and slight creepiness of the displays are closer to my feelings about Christmas than, say, the pure horror of Winter Wonderland, but there is still a disconnect; the sense that the joy of Christmas is an emotional state that I don't seem to be able to access.

The displays that draw my eyes are of perennial shrubs and trees wound with Christmas lights. As we discuss the nightmarish tangles of emotions that trying to live with another person inevitably creates, we come across a tree with silver lights sporadically looped over it. It looks as if someone has scribbled a knot-like formation over black paper in silver pen. Nearing the end of the lane we stop at a house on our left, where a choral version of 'Silent

Night' is emanating from a large gold dome construction on a front porch. We peer through its round window into a disturbing nativity scene: paper mache models of shepherds and Joseph cluster around a cot, uneven marks are drawn on their lumpy faces to suggest facial features. Mary is half the size of the others and a hideous face peers out of her headscarf, grinning down on the sleeping babe like a witch about to place a curse on him. We are both horrified and delighted by this wretched scene.

But Lower Morden Lane is saving its finest spectacle until last. As we near the end of the road something catches our eye, and we cross the street to investigate. It is a large ornamental carp in painted metal, several feet long, protruding from above the doorway of a mock-Tudor semi. The carp has an outline of white Christmas lights and a glowing blue eye. A flashing ornament of Christmas bells flickers below it. Its surrealness pleases us, and we happily consider the thought process that went into making it the centrepiece of the display.

Something about the incongruity of this giant sparkling fish among all the Santas and snowmen momentarily breaks through my wall of numbness; our sense of joy in the ridiculousness of life is restored. We walk back into the centre of Morden, laughing and looking forward to a large glass of wine.

LIVERPOOL

Pilgrimage to a City of the Imagination

POETS

Opposite the Hope Street Hotel in Liverpool's Georgian Quarter is Federation House – an unremarkable mid-twentieth-century low-rise with a row of glass windows below a concrete lid. There are two fashionable restaurants at its base, but it's the walls that interest me. They are encased in a concrete relief pattern made up of layers of interwoven, abstract shapes. Some elements have the quality of shop-bought sugar cake decorations from the 1980s, but with a definite 1960s aesthetic, echoing the organic abstraction of Henry Moore and Barbara Hepworth. The shapes weave into each other, then over repeated textures that suggest drag-on scales, and then come together in circles lined with tooth-like protrusions. I later discover that this is the work of William Mitchell, an artist who pioneered large-scale bronze and concrete reliefs, specialising in public artworks. Looking at this surface, it's as if a tormented but not entirely malevolent monster had a curse placed upon it, setting its essence into a semi-relief surface pattern, to stand frozen for eternity in shadowed monotone.

This sense of a spirit or life force trapped inside the stone confines of a grey building is something I will experience throughout my time in Liverpool. Today,

I am chasing street names mentioned in *The Mersey Sound*, the much loved poetry anthology by Brian Patten, Adrian Henri and Roger McGough. As a teenager, these poems full of wry humour, joy and lyricism were like a blast of colour, connecting the silliness and joy of childhood with the emotional complexities of adult life. They formed a multicoloured cityscape in my mind: a Liverpool drawn in the style of John Alcorn, where flowers erupt from

the paving stones behind you as you walk and pigeons recite poetry in large speech bubbles above your head. Like any imaginary landscape inspired by literature, music or other non-visual art forms, the technical and structural details are hazy, but the colours and light and feel of the place are as vivid as anywhere you've actually been. This imaginary world belongs only to me, and everyone who has enjoyed

31

these poems will have their own fantasy version of Liverpool.

Also known as Canning or the Hope Street Quarter, this area was originally developed in the late 1700s to house Liverpool's wealthiest merchants. It fell into decline in the early twentieth century and large parts became derelict, but the area has been regenerated in the last 60 years. We are following innocuous street names loaded with associations from the poems. It's as if I am in two cities at the same time: the landscape of my imagination, and this world of imposing, grey buildings and cobbled streets, not a multicoloured daisy in sight. But while grand and wintry, there are little clues or portholes into the psychedelic. Passing the Philharmonic Hall on our right, the glass on the doors is decorated with abstract musical instruments and note patterns, like music visualised but frozen in time, much like the dragon on Federation House.

We cross over to the Philharmonic Dining Rooms for a warming pie and ale. This art nouveau wonder is rightfully famous for being one of the most ornate pubs in the country, commissioned in the late nineteenth century to be built in the style of a gentleman's club. From the outside the pub resembles a neo-Gothic pile; the entrance gate features heads of maidens in both silhouette and face on, intertwined in the black-and-gold ironwork. On entering you find yourself inside a series of cavernous rooms, every inch decorated with ironwork. Intricate motifs of golden botanical patterns adorn the walls and soulful maidens strumming on lutes are immortalised in the arched stained-glass windows. As an interior, it has a

unique atmosphere, both palatial and awe-inspiring, and yet its function as a pub, the friendly staff, menu of burgers and pies, and modern pop music blaring from the speakers render it homely and utilitarian. And something in this chimes with the psychedelic Liverpool that exists in my mind.

Turning right up Catherine Street, not a soul is around, but peering through the dimpled windows of the Blackburne pub we see drinkers huddled in a cosy, fire-lit room, injecting the chilly dignity of our surroundings with warmth and humanity. Passing the Byzantine-esque Saint Philip Neri Church my eyes are drawn to a bare foot saint, who looks as if he is hovering just about the ground on the art nouveau frieze at the church's entrance.

Cutting back down through Little Catherine Street, the blackened head of Liverpool Cathedral peers over rooftops. Its little towers look like devil's horns, the two arched windows of the tower are eyes. I feel that it is watching us, and the atmosphere changes; I'm less at ease in its presence. It follows us down Percy Street, past grand, classical buildings, and back onto Hope Street, where we are faced with the full view of the cathedral. We look down into the sunken St James's Gardens, which are dark and forbidding. It's late December and I'm recovering from severe flu; my imagination, ignited by my rich inner version of Liverpool, starts to take a darker tone. I sense a malevolent force in the shadowy gardens and wonder if this is what has frozen the dragon in the stone and the lute-strumming maidens in glass.

You can always find a tour bus in a historic city and here, of course, they feature yellow bubble writing. As a lifelong Beatles obsessive, this Magical Mystery Tour has the gravity of a pilgrimage for Ross; he hopes in some abstract way that seeing the places mentioned in songs and his heroes' childhood homes will bring him closer to them.

Dingle is a traditionally working-class area. The small, Victorian, red-brick terraces of Ringo Starr's childhood home are closer to the Liverpool of our imaginations (minus the eruptions of animated flowers of course). Except as the coach slows down I realise something isn't right: all the windows and doors are boarded up, black. It's a sobering sight, like seeing rows of faces blindfolded. Our guide informs us that these streets were due to be demolished to make way for new property developments, but have recently been saved.

As we weave around Princes Park my eye is caught by a sliver of Victorian terraced street dressed in a mural suggestive of community arts projects. It's an area of bright colour on an otherwise muted canvas. Veering left, the splash of colour vanishes. I feel as if I've glimpsed an embodiment of the joyful, lyrical creativity that vibrates beneath the grey and brown Victorian brickwork of this city.

Onwards we go, around Princes Park and Sefton Park, with our guide imploring us to be careful at our destination, Penny Lane, as we have to cross a busy road to get to the Penny Lane street sign at the quieter end of the street. We are at

33

a rather anonymous crossroads, by a park and the sports grounds of a boys' public school. Ross and I and tourists from all over the world trot dutifully out of the coach to take photos of each other and ourselves by the sign. I feel nothing other than a vague sense of amused embarrassment, imagining locals inwardly rolling their eyes at us.

Back in the comfortable warmth of the coach, we trundle along into the heart of Penny Lane; the song blares happily in our ears and our guide regales us with trivia related to its lyrics. I once again find myself reflecting on imagined places in art and the captivating worlds they create in our mind's eye. Penny Lane is a pleasant enough suburban street, seemingly thriving, sporting sturdy Victorian architecture, but it is not the colourful, joyful place the song depicts. Still it's nice to be in this warm coach and seeing the sights, but I know there is nothing here we can find that doesn't already exist within us.

You have to shuffle through an alley to reach George Harrison's red-brick terraced house. Our guide encourages us to imagine how cramped it must have been for a family living there. I try to visualise

a tiny George Harrison living in it, surrounded by parents and siblings, but my imagination fails me. We carry on, deeper into leafy suburbia, and stop to admire both John Lennon's and Paul McCartney's respectable-looking childhood homes. Again, I struggle to picture these iconic men as children in these most ordinary surroundings. But perhaps that is what we are here to see, how talent is nurtured in these unremarkable places, and it's seeing beyond the everyday to the magic that lurks just below the surface that makes an artist.

The gates of Strawberry Field, the grounds of the former children's home where John Lennon played as a child, have a bit more glamour to them. The bright red ironwork with a strawberry motif, with overgrown foliage behind it, in the dimming afternoon light suggests more romance than any of the other sights.

On our way back to the city centre, our guide, who is clearly as much of a Cilla Black enthusiast as he is a Beatles fan, puts on 'Anyone Who Had A Heart' and proceeds to describe her recent funeral procession, the streets lined with mourners paying their respects to Liverpool's most-loved daughter. These streets are now empty, apart from the odd person getting into a car or taking out a spaniel.

Back on Hope Street, our guide tells us how John Lennon defined fame as not being able to go for a drink at the 'Phil' without being recognised. Imagining him ordering a drink at the bar of our temporary local gives Ross and I an unexpected feeling of genuine delight.

On a wet winter's day, Liverpool Metropolitan Cathedral's slabs of grey stone seem to perfectly match the sky. The cathedral was designed by Frederick Gibberd and completed in 1967. Long spikes poke up at the sky from a cylindrical crown on top of its concrete dome base. Part brutalist monument, part spacecraft, it stands majestically; its esoteric geometric relief stands out like shadows on an overexposed black-and-white photograph.

At the entrance are two huge sliding doors, featuring terrifying patterns cast in bronze; they suggest stone slabs at the doorway to an ancient temple. Again, they are the work of William Mitchell. A large, contorted and monstrous bird sits against an agonised human face surrounded by ragged, concertinaed forms, protruding at an angle over the edges of the slab. The wild eyes of the bird and the face combined with the unforgiving quality of bronze make these trapped beings feel even more desperate than the concrete monsters of Federation House.

I admire the uncompromising appearances of both cathedrals, which fight for dominance over the city of Liverpool at each end of the aptly named Hope Street.

On entering the nave, a feeling of contented well-being comes over me. The large domed area is calm and welcoming, contrary to the exterior. I am transfixed by the abstract, watery patterns in the triangular stained-glass windows that suggest amoeba or cells splitting and multiplying. Spaced out around the circular space, on its large columns, are cheerful embroidered wall hangings of Christ. One has the simple and reassuring look of a PLAYMOBIL figure, a silver star behind his head, arms outspread, with ships and jagged rocks at his feet, all deftly rendered in fabric. A priest tells us these hangings were made about 20 years ago by Sister Anthony; I marvel at this prolific and skilled nun

There is a wonderful, mid-century mural in a side chapel. Latin words sit on areas of block colour, shapes of a dove and bells overlay the coloured forms. In the bottom left corner is a graphic depiction of baby Jesus, his face peeping out of a cocoon of swaddling cloth rendered in triangles in various shades of white and cream. The naive and colourful delights contained here are perhaps the only things I've seen that connect the technicolour Liverpool of my imagination to the actual city. The last place I expected to find it was in a Catholic cathedral.

PORT SUNLIGHT

The Factory Village

After travelling by cab, under the River Mersey and through anonymous industrial areas, we have arrived in a spacious land of softly curved greens, whose angles widen and gently distort as your gaze shifts across them. We walk along King George's Drive. On our left, trees teasingly conceal the grey expanse of the Lady Lever Art Gallery, which sits solidly like a giant tomb. On the right side sit Arts and Crafts cottages, and we walk towards a row of low-roofed dwellings which curve around the bend, the sweeping dip of the roof and their cream shutters creating the impression of terraced Disney cottages. Rounded perennial shrubs nestle up to them snugly.

We are exploring Port Sunlight, a 'model village' created by the industrialist and philanthropist William Lever (later Viscount Leverhulme), for the workers of the Lever Brothers soap factory, on the other side of the village's wall. Created between 1894 and 1925, and designed by some of the era's most prominent architects, including Sir Edward Lutyens, the village was intended to embody Lever's lofty ideals of community, health and clean living.

It is freezing cold and damp, with a heaviness in the air that seems to pervade the surroundings, dulling the white. On St Mary's Drive, parallel to a narrow green, we pass a series of mock-Tudor houses – the patterns vary from cottage front to cottage front; spade shapes sit in regimented rows on triangles of black alongside bold herringbone. Further cottages in this series incorporate red brick into the motif. Port Sunlight is unique in model villages of its time for employing such a range of architectural styles and architects within the same development. I feel like I am walking past a gradually evolving

pattern where themes reoccur, but differently each time.

Following Jubilee Crescent around past the war memorial, we turn onto Bolton Road. Here a row of red-brick neo-Gothic cottages sits, like miniaturised versions of late-Victorian Chelsea mansions. Straight ahead is a no man's land of railway tracks, and it's like we're walking along the edge of a film set of an idealised Victorian working community. I have this ominous feeling that I am trapped in an illusion. As we curve around the edge, down Greendale Road, we can see the impressive structure of Lever House, the original Lever Brothers factory. Its haughty and decorative facade peers over the grand entrance at the end of Greendale Road. I imagine that this is the only way out of the village, into the factory, and that its inhabitants were otherwise benevolently imprisoned.

Bath Street features further rows of cottages clad in black-and-white timber. However, here, the triangular fronts are white, with intricate decorative motifs of plasterwork featuring cherubs framed in swirls and flourishes. The contrast between the subtle white-on-white intricacy arranged alongside bold black-and-white patterns pleases me, like a drawing rendered in dramatically different-sized pens.

Further around the green sits the red-brick, late-Victorian Gothic of the Lyceum complex, once serving as its school and church hall. This more imposing style of architecture fits the atmosphere better than the forced cosiness of many of the cottages. Looking across the green, a row of red-brick Gothic houses meets the wall and modern industrial buildings emerge behind it. This is one of the rare points in the village where the skilful planning fails to mask its geographical context. Lever's industrial success was largely a result of his pioneering advertising and publicity skills, and as I look at this strange barrier I realise that Port Sunlight itself is in many ways part of the elaborate illusions he created, this time embodied in brick and plaster.

We come across the Bridge Inn: a tavern constructed in 1900; it's a reassuring combination of black timber and white

and red bricks. The interior, however, is deeply uninspiring, drab and generic, the darkness interrupted by the bleep and colour of fruit machines. It's as if the village's disguise has been lifted and we've seen the true character of this place.

Making our way along Church Drive, we notice how little personalisation there is; there are few clues about who actually lives here. Aside from the odd bedraggled Christmas wreath, gardens are planted in a similar fashion and front doors all match. The personality of the place is closed and unknowable. When Port Sunlight was created, there were strict guidelines as to the behaviour and lifestyle of its inhabitants, so to a certain extent workers exchanged personal liberty for high-quality, affordable housing. But the working class were becoming increasingly politically mobilised, and this idea of a benign 'Lord of the Manor' was outdated. Many Lever workers refused to live in Port Sunlight, in spite of its low rents and mod cons. Although most homes are now privately owned, this sense of conformity still pervades Port Sunlight.

We find ourselves back at the Lady Lever Art Gallery, founded by Lever in memory of his wife, Elizabeth. As we admire the intricate textiles and carved furniture, it is difficult not to think of Viscount Leverhulme's less pleasant international contributions, such as his interests in the Belgian Congo, where he established a palm oil factory and even built a workers' village in the jungle, called Levertown. His involvement coincided with the horrific rule of the Belgian King Leopold in the area, and it is widely thought Lever was complicit in the atrocities inflicted upon the native population.

Admiring his small collection of naive folk art, I feel like for a moment I am witnessing something intimate, something created for the love of making rather than to demonstrate the wealth and opulence in its owner. These pieces, however, are the exception not the rule. As I wander through, I get a sense that the gallery is somehow the centre of the maze that is Port Sunlight; its heart. Yet even at its very core are further corridors where surface and illusion rule.

BATH TO BATHAMPTON

Waterway Out of the City

A brittle sun is shining; it's one of those early spring days where sunshine is interrupted by abrupt and fierce showers, and there is fragility to the light. Blue sky and clouds shine up from puddles on the towpath. Bath is beautiful, but the homogenous architecture that dominates its centre, combined with its chic affluence, has always left me slightly cold, as if wandering around a gorgeous outdoor museum. Walking the canal you gain a more genuine connection to the city.

The Kennet and Avon Canal was developed in the late-eighteenth century and transported large quantities of stone. Now it exists largely for leisure and wildlife conservation, and indeed it is hard to imagine this place having an industrial purpose today. Walking under Sydney Road's old bridge we are mesmerised by shadows of the reflections of the canal shimmering on the curved surface of the wall, the water, light and stone all intermingled in a tunnel. The stone feels alive and pulsing.

The path begins to rise, and we are treated to a view of Bath rooftops, not the city centre but its suburbs – rows of small gold-grey shapes petering out to brown miniature tree skeletons. In a brambly growth sprouting on our left, we spot a rabbit, shivering in the leaves.

A scrubby slope
of common land, where
ponies graze, emerges on the other side of the water. We are
still officially in Bath but are getting to that part of the city where
the rural begins to creep in. It happens more suddenly in small-
er cities, and there is a happy inevitability about it here. Behind
a gentle green bank is a development of 1960s' detached
houses, but with extremely pointy almost witchy rooftops. My
companion, Alice, a Bath local, says she has always had a soft
spot for these houses. Their architectural style is so ordinary
in comparison to the grandeur of Bath's more celebrated build-
ings and yet they have been rendered in the same, pale honey
Bath stone; they're all connected to the surrounding geology.
Bath is an extension of its natural setting, not at odds with it.
The houses light up and glow in the sunshine, glimmering
visions between dark overgrown trees. The trees clear and we
get a better view of them. The rooftops are reflected in water
and they seem to be pointing deep into its depths.

We are coming into Bathampton proper. The houses here
are old but simpler, more villagey. Strips of extremely narrow
garden lead down onto the water, where upside-down clouds
and trees float and glisten.

41

MANCHESTER

The Land of Red Brick

At the Tibor Reich exhibition in the Whitworth Gallery, Manchester, I watch a video about his design process. The clipped, 1950s' voice of the narrator sounds almost parodic as he describes how Reich created his rich, printed textile designs by photographing textures found in the world around him, be it the grass beneath his feet or the wall of a building, then increasing the contrast of his photographs and arranging them into patterns in order to 'interpret rhythm, light and shade and add to it ideas of his own'.

Tibor Reich was an iconic mid-twentieth-century British textile designer whose abstract prints were hugely popular and featured in numerous civic projects, including the Festival of Britain and Coventry Cathedral.

We have walked here from Stockport, through suburban streets of semi-detached houses, past main roads, industrial parks and leafless February trees. In the chilly drizzle, I've struggled to connect visually to my surroundings or know where to put my focus. But now, looking at Tibor Reich's prints – the energetic, loose but graphic marks over rich colours embedded in textured fabrics – I am able to look back on my walk and visual patterns begin to emerge: the mass of branches behind a wire fence when we peered into allotments, diamond-shaped wooden panelling incongruously on the side of a warehouse, the topiary of privet trees in suburban front gardens.

It was chiefly Manchester solicitor Robert Dukinfield Darbishire who established the Whitworth, in 1889, on behalf of Joseph Whitworth, and its collection today is largely made up of twentieth-century British art and textiles. The experience of being in the Whitworth helps me find a way to process suburban Manchester. While Tibor Reich was Hungarian in origin and worked largely from the south-west of England, his abstract reinterpretation of his surroundings fits comfortably

with this city and its suburbs. Perhaps it's because the respectable semis I've been walking by are exactly the sort of places that his textiles were designed to upholster.

Part of the video that particularly chimes with me is the description of the creation of 'Florida' (1957), a fabric inspired by the surface of a brick farmhouse discovered on a family holiday; energetic marks of black, white and red on white strips of brick-like texture. One of my abounding impressions of Manchester so far is the redness of its buildings. Indeed, before I came here, I always visualised Manchester as a red place. It is the iron-rich clay, which built Manchester during the Industrial Revolution, that gives it such a deep, confident colour. Later, as the light is dimming, we walk through the centre of Manchester: patterns are everywhere. It is Chinese New Year, and in Albert Square red lanterns hang from the trees and green foliage is projected onto the grand Victorian buildings, almost uncannily echoing the fabrics we've been admiring.

DUNGENESS

Rust and Sea Kale

Driving into Dungeness you enter a strange and flat world. The light is hazy, blue sky almost detectable under a light fog, but my friends assure me that this is perfect Dungeness weather; if it were sunny it would just feel wrong. Looking out across the shingle, dotted with timber-framed dwellings and other more cryptic structures, I agree with them. The sky and shingle are close in tone, adding to the feeling of misplacement. Dungeness is known for its eerie 'end of the world' feeling, created by the run-down houses, decaying boats and the looming silhouette of the power station all across flat shingle. Guy comments that it looks like where a serial killer might reside. While certainly finding it odd and mildly disconcerting,

there is something calming about this bleached-out, open beachscape.

We park at the Pilot Inn and head out in a south-westerly direction, following the faint grey block shapes of the power station on the horizon. We pass a faded empty white clapboard building. Its greenhouse has had the glass smashed out of it, and the shapes created by the empty frames crop and isolate segments of the view. Nick tells me that, due to the fragile ecosystem, structures that are no longer in use cannot be demolished but have to just gradually fall back into the land, and this explains the graveyard feel of the place. I imagine a desert scene, ribcages of animals erupting out of the earth.

The extreme flatness and emptiness cause me to struggle to know where to direct my gaze, and I find myself looking down beneath my feet. Without varying altitudes, trees or plants, there is little to anchor my attention, and this is disorientating. The ground changes from hummocky, scrubby grass to pebbles, and we

are met with an area of shattered glass, possibly what used to reside in the greenhouse skeleton. The jagged planes place a dulling, grey-blue filter over areas of orange and white stones. Little areas made up of several species of spongy moss emerge from the pebbles. It's as if I am looking down on the canopy of a forest island in a sea of shingle.

Nick emerges from behind a gorse bush with two lumps of rock that look distinctly extraterrestrial, one black and one green and gold. We speculate about their origins. It's interesting how this flatness seems to actively encourage us to pick things up from beneath our feet.

The landscape becomes increasingly green as we near the power station, the arid dryness of sea moss and stone is replaced by grassy hillocks, which look distinctly like the reindeer moss used by model railway enthusiasts blown up to actual size and covered in swishy blades. We pass a boggy puddle that on closer inspection features the rainbow sheen of petrol. Orange-coloured soil and stone underneath it causes the blue-black to merge into decay. Framed on one side by orange pebbles and on the other by yellow-green grass, there is something toxic and unnatural about it.

Following the curve of the headland around to pass the power station, we are on the beach and a thin line of grey sea lies on top of the shingled horizon. I start noticing little clumps of sea kale: purple frilly leaves, bunched together but sturdy like succulents, growing out of cross-looking twisty brown roots, which make

me think of mandrakes, with ten or twenty protruding tubers. There is something so pale and seemingly barren about Dungeness, but it hosts such a range of heroic plant life.

The flotsam and jetsam begins to become more impressive; Nick and Alma's terrier–lurcher puppy discovers a tangled, rust-orange fishing net and wages battle with it, shaking it in her mouth and growling as Nick drags her along. Her sandy fur, orange net and orange pebbles camouflage each other. The colour palette of Dungeness feels very carefully and tastefully rendered.

Back on the tarmac, we come to a bungalow featuring faded-green window frames, one round like a porthole. It is very much abandoned and its paint is faded so that the black perfectly emphasises the wood grain. It seems to have sprouted up from the spongy, grass mound it sits upon like the sea kale did from the pebbles.

Dotted along the horizon and semi-hidden against the surface texture are structures suggestive of boats and huts. The rusted remains of a railway line reach out towards the sea. I wander across and begin to weave my way around these strange monuments. As I near them their shapes emerge: a sun-bleached wooden boat on its side, a faded semi-dilapidated timber shed, a large engine rusted to a warm glowing orange. I get closer to a decaying hut and see someone has scrawled 'Show us your willy!' on it in purple spray paint. This vulgarity, while jarring, brings this place back down to earth. Alongside the rusted remains of a railway track lies a tangle of fishing line and weights like a mass of wavy, silver hair.

We walk back inland to visit Derek Jarman's garden, Prospect Cottage, where stones are laid out in circles according to colour and size. While they have been purposely arranged by hand in accordance to a creative vision, to me they are less harmonious than the accidental arrangements on the beach. Making our way back to the

car park later, we pass piles of purple rope sitting in a front garden of a house proudly bearing UKIP posters in its window. It looks as if there could be sea kale growing out of the grass. Passing a faded house sign in the shape of a dolphin, again almost camouflaged against the pebbled backdrop, we make our way back to the inn.

PORTMEIRION

The Giant Folly

The arched, pink Italianate building ahead features heraldic symbols that are pure folly, there for effect as opposed to any deeper symbolism. We are entering a grown-up Disney World for the discerning lover of niche architecture. Conceived, designed and built by architect Sir Clough Williams-Ellis between 1925 and 1976, Portmeirion is a holiday destination on the north-west coast of Wales in the style of an Italian village.

Although the architecture is what I am here for, as I walk through the arch the first thing that hits me is the view. Planted formal gardens lead down to a circular viewing point, and beyond that is a vast stretch of sand flats which eventually meets hazily coloured mountains in the distance. We walk down, the path flanked by blossoms and daffodils, and a cypress tree, all radiant in the spring sunlight. As we step onto the viewing platform

I notice an understated stone statue of a mermaid, almost Eric Gill in style. It is faded by the elements and its lack of definition is at odds with our surroundings.

As I look out, I am captivated by the silver expanses of shallow water spreading out ahead of me; they wind and curve and split, the smooth sweep of their edges curling inwards and becoming delicate frills. I keep shifting my focus from the sand as the solid element to the expanse of the water The sand is edged by silver, one of the flats nearest the shore curves around and then juts in at a right angle, and it directs my gaze to the white tower marking the edge of The Hotel Portmeirion before the coastline curves. It seems that even nature is co-operating with Williams-Ellis's aesthetic vision.

Further along the walkway we come across a grotto, and on entering we find the window surrounds and bars painted a bright, Yves Klein blue. The blue is illuminated by the light shining through it, glowing like a colour of the Mediterranean, infused with the force of warmth and sun. It's delightful and almost physically invigorating to observe. The walls surrounding the ceiling are covered in patterns of scallop shells; the contrast between the classy elegance of the blue and the kitsch quality of the shell motif is deeply satisfying.

Nearing the hotel, passing a circular outdoor pool, there is a perfect alcove of brilliant blue with a turquoise bench and a yacht melded by concrete. We pass a white statue of the Virgin Mary that stands beside camellia trees and whitewashed stone; I take a photo of her on my phone, and with the glowing white of the statue and blue of the sky it looks like a holiday snap from Greece. It is mid-March; I speculate how different this experience would be if we hadn't been so ridiculously lucky with the weather. Under a menacing overcast sky would it become sinister or depressing? I feel that we are experiencing Portmeirion in the conditions Williams-Ellis built it for.

We pass the watchtower of the hotel with its pointed star silhouetted agreeably against the sky, and walk down onto the beach. I become entranced by the texture of the sand formations underfoot. They seem like scaled-down versions of the swirling networks of the water on the sand flats. On reaching the corner we meet the doll-sized lighthouse. It is nestled among lichen-covered craggy rocks, which become blacker as they near the sand.

us up the slope which frames a pink building behind it. My eye stays on this frame as I walk, letting the picture gradually shift. There is green ironwork covering a porthole that nestles in local stone, which delights me as it looks like something I would draw in my sketchbook.

I look out onto the Central Piazza with its fountain and turquoise iron benches, neatly arranged. I think of *The Prisoner*, which was filmed here, the fountain stopping when there was an announcement, and how much bigger the town looked on TV. The house at the end and the pink town hall at the back honestly look like something out of Sylvanian Families. The whole town is an illusion; its levels and positions create a sense of space and depth that is not really here at all.

Standing at the edge of the pond, I look up at the most authentically Italianesque buildings I have seen so far – behind the cypress trees, their shape resembles structures I have seen in Tuscany, but the bright turquoise shutters give away their true origin. Making my way up terraces and hills to admire the village from different levels, it dawns on me that it is like being in a living painting or early twentieth-century textile pattern in three-dimensional form. I'm exploring this small space from a variety of viewpoints in order to admire the endless combinations of satisfying colours and shapes, which makes much more sense than trying to relate to it as anything real or functional.

Attractive painted signs emerge out of blue corners of buildings. On the corner balcony of an orange building, a garish

Walking up through the trees inland it is a relief to suddenly be cool and sheltered. The view is still visible, divided into segments through the mesh of naked branches. The beech trees' wavy branches protrude like reaching withered arms. I come across a tree stump with two-pence coins shoved into it; a phenomenon we find further up the path in an actual tree. We wonder, is it a tradition like a wishing well? We come across the most marvellous sequoia tree, which confirms the enchanted-forest atmosphere of the place. It has a branch thicker than the trunk reaching down and up again, so it's almost a double tree. It is as if everything has been rendered by Mary Blair. The artfully placed splashes of colour made by camellia bushes add to the effect and remind us that we are walking through a constructed landscape.

Heading towards the village, I peer through a red decorative arch ahead of

sculpture of Jesus or a saint rests under an umbrella-shaped funnel coming from a drain. A black sheep emerges from this little balcony like an old-fashioned street sign. It dangles as if to be lowered by a crane.

We cross back to admire the ceiling of Hercules Hall, purchased by Clough Williams-Ellis, depicting the labours of Hercules. This elaborate plasterwork seems tasteful and subdued in comparison to the town's exterior. I look out of the hall's window and the view has suddenly had a grid placed over it. Each square is a perfectly composed little scene.

THE FFESTINIOG RAILWAY AND TANYGRISIAU

Steam Train into Snowdonia

The interior of the Ffestiniog Railway steam train is a delight to behold. Red velvet seats feature a subtle gold-patterned 'FR', and a map of the route is inscribed onto the varnished wooden tables. Two elderly northern couples in fleeces a few of tables away are having a very involved conversation about their preferred brand of crisp. The train begins to move with a loud whistle and we are surrounded by white smoke as we pull out of Porthmadog station

The train is moving over the estuary crossing, the mountains of Snowdonia to our right and endless sea flats fading out towards the coast on our left. As we travel up into the Moelwyn mountains, stopping at the hamlets of Minffordd and Penrhyn, my eye is caught by a small, home-made garden shed with a bush growing out of it, then a sheep, grazing close to the tracks, with numbers written on her off-white wool in purple, bright green and orange. The colours momentarily cut through the grey and muted tones that dominate the scene outside. At Penrhyn Station I find myself looking out of the window on the opposite side, gazing at fish-scale-shaped slate tiles.

Further up, the landscape becomes wilder. We are winding along the side of the mountain, a tangle of beech, bracken and silver birch blocks the downwards view. A barren hill emerges alongside as we continue upwards, with rough yellow paths that smear across scrubby purple land. Suddenly, this drops, and we see over the edge to the valley below. Mountains of pale copper, grey-green and soft purple look down upon bright green boggy fields. The sudden drama causes tears to prick my eyes, but no sooner have I processed this than the train seems to wind back into the heart of the mountains. Steam blows out and creates a white fog over the view, as if part of it has been momentarily erased.

The trees thin out again revealing a large pool in pinky, coppery soft scrubland. Lumps of pink puncture the surface of the water like boils; the landscape is becoming stranger. The water opens out onto the estuary, surrounded by craggy mountains of lead-grey and pale copper.

The train pulls into Tanygrisiau, a request stop on the Ffestiniog Railway and a tiny hamlet. I am the only one to step onto the platform. It's silent around me after the train pulls away; the air is fresh and cold on my cheeks. A group of railway volunteers are clustered in the little shelter, so I stop to talk to them, to enquire

the best way to get off the platform, as it seems as if I am trapped there. I tell them about my plans to walk across the nearby slope to Llyn Stwlan. The ringleader proceeds to tell me in great depth about the industrial history of the area, how workers ascended the mountains on Mondays to mine peat, and slept in sheds, but it was a cut above being a farm labourer. But I am keen to get going so I make my polite excuses and set off on my little route.

I am using a guidebook I bought in the Porthmadog Tesco, and I am ashamed to admit that I brought no map with me. Naively, I had assumed there would be some sort of shop at the visitors centre on the reservoir, but on investigation it doesn't seem to sell much beyond bara brith and tea. Still, I spot the first ladder stile that I'm meant to clamber over, and the directions seem fairly straightforward.

The slope I'm ascending is a gradual and chaotic combination of upwards slopes and gentle plateaus, the iron-coloured bedrock thrust out regularly in a wave-like formation. The ubiquitous pale-pinky copper combines with a pale off-yellow, and leads up to the rocky peaks. I clamber over, practically skipping. Following the written instructions, I am seeking a stream to serve as a landmark. When I find it, I follow it up to its source, the fresh water rushes over glistening black rocks making the loveliest noise. If 'feeling refreshed' could be distilled in sound form, it would be the babble of this mountain stream. I have a strong sense that the mountain is alive; it's as if the skin has burst open but what flows through it

is pure and cleansing. The black rocks make the water look black. I'm oddly reminded of my childhood dog, a Border terrier–Jack Russell cross, who beneath her sandy fur had black skin in places.

Unlike a flatter landscape, I feel less inclined to look down at the ground below me; I'm continually awed by the shifting

perspectives of the surrounding crags and slopes. But I start to pay attention to the surface of the rocks. They are covered in detailed lichen patterns of green, orange and yellow, occasionally their delicate edges tipped with pink and blue. Zooming out again, to absorb the vast and infinite valley, I think how this world is complicated pattern inside complicated pattern, worlds within worlds within worlds, and you can observe it from a distance or wander among it, as I am doing on this mountainside.

Looking back down towards the valley, again the magnitude of the view causes a lump to form in my throat. I then spot the second stream I'm searching for as my path to follow on this route. It's a winding, black line, sunken into the moss. I let out a whoop of joy. I peer inside it and a layer of the deepest green lines the black,

slippery rocks. Feeling very authentic, I scoop up a few mouthfuls with my hand. It is cold and minerally. As I trot upwards and onwards, I feel like this stream is my companion, its trickling sound keeping me company. I hear shouts in the distance; I look in the direction they're coming from and see tiny people hanging off the crags.

I wind my way just above the rocks, which jut out of the ground in different forms; there are nestling rounded boulders, and some are jagged energetic thrusts that make me conscious of the violence of geological movements. I start feeling concerned that this stream doesn't seem to be leading me anywhere in particular – I spy another stream across the plateau and decide to wander over to investigate. I soon regret my lack of faith in my navigation skills when, as I near the stream, the ground gives way under me and I am up above my boots in bog.

I manage to pull myself out, cursing. My mood quickly sinks, from the elation of minutes earlier to misery and embarrassment. Soggy-footed, I make my way back to sturdier ground, but even my discomfort and shame can't dilute the awe I feel in my surroundings. I decide to abandon my mission and head back the way I came but, before I turn back, I spy a particularly dramatic outcrop of rock with a grassy bank leading up to it. I clamber up and sit on its edge and remove my soggy socks. The outcrop gives an illusion of a cliff's edge, and I sit surveying the vast cavern of the valley bellow, a patchwork of smeary steel grey, yellow and brown, with the metallic surface of the estuary shining dully, and I feel momentarily like a queen surveying my realm.

Returning, the downwards slope gives me more momentum and I almost tumble down the hill. I follow the same stream, and grudgingly forgive it for disappointing me, still reassured by its watery chatter. Although I'm retracing my previous route from a new angle, rock formations and the twists in the stream are fresh and surprising. I notice new details on rocks, little black patches of moss alongside ice-blue lichen. At the stream's edge, I see a rusted piece of machinery, some sort of tap or a bolt. The presence of something manmade in these surroundings seems completely incongruous.

I reach a point where the slope of the hillside flattens out to an area of soft, lumpy, dry grass. I lie down and it is utterly comfortable; with my head resting on a soft hummock, I stare upwards at the grey mountains, embraced by cloud.

Back in the valley, after a brief stop at the visitors centre cafe for a now much-needed tea and bara brith, I head onto the station platform to flag down the steam train. I come across an elderly lady sitting in a wheelchair, three yapping lapdogs with huge ears on her knee. She asks me about my walk and proceeds to tell me how she used to work for National Trails. She introduces her papillon dogs to me, who look like they'd be more at home in a Manhattan apartment than this rugged landscape, and is busy telling me all about their feats in Crufts when the train appears in a cloud of smoke and noise to take me back down the mountain.

GLENARIFF WATERFALLS

Deep into a World of
Moss and Water

Crossing over a small stone bridge, we look down into a wound-like crack in the hillside, where the mossy stones separate and a white disjointed line of water busily rushes through it. Beside it, the white bark of a silver birch is adorned with a lone lump of bright green, fluffy moss.

Here in Northern Ireland, spring seems to be a few weeks behind southern England. The hills surrounding us are covered in pale trees, largely leafless, creating a delicate, crackly texture that envelop us as we walk. But closer to our feet, the ground is covered in a curling carpet of moss with ferns bending up towards us.

We pass a marvellous pine tree. Unusually, a few of its lower branches snake inwards and down, and one branch in particular curves and coils downwards like the banister on a spiral staircase.

The roar of rushing water becomes more powerful and draws our attention away from the complexities of the plants around us. We are now at the top of a wooden walkway. It descends into the ravine, winds around and crosses over itself at angles, creating a graphic pattern over the delicate rushing water and the ferns. I had been looking at nineteenth-century

Japanese kimono textile prints that morning online, and the combination of the wooden structure with the flowing, organic forms it frames, uncannily reminds me of them. We laugh at the oddness of being transported to Japan in the middle of rural Northern Ireland.

Rounding a bend, I witness a hugely spectacular waterfall, it is two-tiered and powerfully pummels down with great force. Peat from the soil gives the white foam a rusty tinge at times, like mud on the fur of a white dog. While forceful, it also feels benign. A few metres away is another waterfall, this one is long and thin like a line against the dark grey rock; a bolt of lightning, softened at the edges. We speculate as to how different their personalities are, how, in spite of being less dramatic, we prefer the poised understatement of the slimmer one.

There is a detailed, mossy, ferny weeping world on the walls of the ravine as we make our way along the footbridge. Each part of it has its own character. Some parts of the walls are lumpy and moss covered, in deep browns and reds graduating to bright green. Others are covered in ferns in an almost jungle fashion. Water runs down the walls, in some places at the intensity of a bathroom shower, in others, slow and gentle from the foliage, the droplets looking like tiny jewels shimmering in the light. From a distance these little waterfall walls glisten. While the large waterfalls are undoubtedly spectacular, these miniature, vertical landscapes are mesmerising. We notice a miniature waterfall at the back of a little cave that is just waist height.

The outside of the cave is carpeted in a roof of ferns and moss-covered roots. We speculate about the wealth of mythical creatures that could potentially inhabit it.

Further along the footbridge we are surprised by a restaurant perched in the ravine. We then turn a corner to witness perhaps the most spectacular waterfall of all, which pours down into a wide grey pool. It's so wide, it is almost squat. As much as the idea of an eating establishment in the middle of a waterfall forest appeals to me, the restaurant's proximity to the waterfall gives it an increased sensation of a tourist attraction.

On the last stretch of our walk, the landscape opens up again. We look out at The Glens. They stand static and ancient, yet the way that the hill slopes down in a combination of soft curves and serrated ridges reminds me of a crest of a breaking wave. These glens and ravines were formed from glaciers in the Ice Age, and something in the movement of the slope flattening into spiky planes suggests a splitting iceberg or avalanche rendered in rock and soil.

Walking through woodland back to the visitors centre, in a clearing covered in brown leaves sit a group of skinny young trees and round rocks, all covered in almost fluorescent green moss. A branch reaches from one tree towards the rocks like a claw.

BELFAST

The Most Beautiful Pub in the World

A grey sheen washes over everything as we make our way through the centre of Belfast in the pouring rain. Finally we reach our destination, The Crown Bar.

Patrick Flanigan renovated his father's pub in 1885. Much of the elaborate stained glass and tiling is the work of Italian craftsmen who were working on churches in Belfast at the time. Flanigan persuaded them to work after opening hours, transforming the pub into one of the finest gin palaces of the era. Indeed, while its purpose is the very opposite, in terms of embellishment and symbolism it is oddly similar to the inside of a church. The bar itself is altarish in style, supported by a similar ceramic tile structure to the exterior. Behind the bar, mirrors are engraved with detailed leaf shapes – they sparkle as if you're looking out of a window into a crisp, frosty woodland landscape.

The bar is divided into several snugs. We marvel at how each is labelled with a letter, and on the arch that divides the room the letters A–I are contained in a decorative frieze; this was the original bell system for serving customers. I walk over to the windows: they are adorned with fleur-de-lis, with lanterns and baskets of fruit hanging from twirls. As well as a crown, each window features an alarmed-looking disembodied face in a triangular hat as its centrepiece. Following the exuberant motifs, they curve up into sad clown-like profiles, with rounded cheeks and long curved whiskers looking like extensions of their faces. The windows' dimpled texture makes them shimmer and blur.

The ceiling is supported by elongated pineapples: dark wood rimmed into segments with gold edges, erupting into leaves up at the ceiling. They seem like scales of the legs of a dragon or a terrible bird. On top of the snug partitions sit carved animals – lions, griffins and other strange dragons.

We nestle inside a snug. It feels very private from the rest of the pub, yet we look up at the same scaled columns and carved wooden ceiling.

We've flown in from London this morning, and I have an 'Alice in Wonderland' sensation of being in gradually shrinking environments. First the skies, then Belfast's streets and into the pub, and lastly into this small booth; yet there's enough detail to examine for hours. There are flowers painted on the panels' windows, like cut outs from Victorian scrapbooks. It seems fitting that this storybook imagery should meet us here at the final destination of our journey inwards.

CASTLE CROM

A Hidden Arboreal World

The ruins of the original Crom castle overlook the shimmering lake and islands of Upper Loch Erne. As we approach, the grass around us is green and boggy, and strewn with unusual trees. We admire a moss-covered oak tree that features a detailed map of orange and green lichen. We pass a dead oak, its hollow trunk full of pieces of wood as if it is storage for firewood.

The silhouette of the castle ruins comes into focus, echoing the shapes of the dead trees that surround us. The castle was originally built in 1611, as part of the Plantation of Ulster by Scotsman Michael Balfour. It was acquired by the Crighton family in 1655, but in 1764 was destroyed in a fire. A new castle was built in 1820 further up the hill, and towers were added to the folly to improve the romantic view.

The information board tells me to go and look at the ancient yew trees, which are part of local folk legend. Allegedly, 'an O'Neill who was attained for rebellion in the Reign of Queen Elizabeth… took leave of his ladye here under the yew tree at Crum'. I walk into the old garden and the yews sit like giant bushes; blackened lumps joined together to make a large dark cloud shape on the lawn. I walk up to its edges, where space in the branches allows me to enter the dark canopy.

Inside, I am in a vast cavern fashioned by two knotted trunks. A thick and chaotic tangle of twisted boughs wind around to the canopy's edges. Little shapes of light pour in

between the limbs, and leaves create a patchwork pattern over the complex mass. I feel like I've entered an enchanted tree chamber; its interior seems vastly bigger than its unprepossessing exterior suggests. I climb over and under branches to reach the middle area between the two trees. There are infinite spaces, angles and twists and turns to this place; it's a magical landscape hidden within a black cloud.

My friend Alice finds me in here and we admire the intricacies of our new realm. We start seeing creatures in the boughs: a thick bulging knot looks like the face of a walrus, a terrible, demonic hog with mad eyes emerges out of the trunk, and several of the gnarled protrusions become prehistoric birds and dinosaur heads. This place, while entrancing, has a nightmarish quality, allowing the visitor to see their darkest demons and terrors in the twists of the trees. Some have knots that give the illusion of suckers and the trees become tentacles emerging from a terrifying sea creature.

In spite of its resident monsters, this tree world feels safe and reassuring. We climb up into the central bough of one of the trunks, which makes a snug platform, hemmed in by branches. Up here are many carvings of couples' initials and names, some of which are barely legible, having grown back into the skin of the tree. I remember something I read by Roger Deakin about the number of babies conceived in forests, as they were the only place where country dwellers, living several to a bedroom, could find any privacy. We don't want to leave our secret realm, but we drag ourselves out, blinking into the light. As we walk away, we can't believe that the squat, little black cloud receding in the distance contains this universe of terrors and delights.

EDINBURGH

Below the City's Surface

When you walk down Hawthornbank Lane, from Dean Village to the Water of Leith, you pass two large old houses on your left. The prominent triangle of the first house's roof is both comical and nightmarish. The next house along is large and yellow, and in need of a coat of paint. The stone doorway on its front facade is long filled in with stones. Above are carved words, which I can't make out, surrounded by a decorative motif where two naively shaped stone angels float above a barely discernible crest. As we descend the cobbles, it occurs to me that these houses could be the gatekeepers to the subterranean realm we are entering.

At the bottom of the gorge the landscape is wild compared to Dean Village; the dramatic arches of Dean Bridge emerge from a mass of almost leafless trees and shrubs

by the water's edge. Beneath one of the arches is a dead tree, covered in ivy; a few spindly branches spike out from the deep green tangle and the ivy forms a turret at the top, which mirrors the turret of the miniature stone castle that protrudes from the wall next to the bridge.

Walking north towards Stockbridge, I peer through delicate branches tipped with tiny fresh green leaves into the rushing brown river below. The lower walls of the waterway are covered in ivy, which flows down in a waterfall of foliage. This overgrown wildness is pleasing and harmonious and so different to the chilly, imposing elegance of the city above our heads. The water's edge is irregular and gently jagged, surfaces of rocky floor emerge like shards of old pottery. Looking back, the ivy tree tower is perfectly framed by an arch that meets the rushing water.

We soon reach a raised stone platform featuring a Grecian statue framed in a circular Roman temple; she looks both isolated and peaceful. It is as if we have stumbled into the grounds of an abandoned stately home in the middle of the city. She is in fact Hygieia, the goddess of health, and this monument is St Bernard's Well, designed by painter Alexander Nasmyth, as it is the site of a natural spring. Across the water, perched among the cascading wilderness is a wooden bench, giving a more residential air to the setting.

Jonny tells me I'm looking at private gardens belonging to the buildings they back on to. I have never coveted a garden more in my life.

We come up for air in affluent Stockbridge for an aspirational coffee. It is like taking sunglasses off; up here is so bright and bustling with smartly dressed, purposeful people, just seconds away from the dreamy, overgrown solitude below.

Descending again, we walk into the Botanic Garden area. The scale of our surroundings is less dramatic than when we were in the gorge. We are no longer so deep beneath ground; the walls up to the world are at more modest heights as we move into Inverleith. Thin gardens lead into slim, three-storey townhouses. The air is becoming increasingly icy. We wind along the river; an elderly woman walks ahead of us with an even more elderly dog. Alarmingly, a crow flying overhead starts swooping at her aggressively, although the woman seems unfazed. We wonder if she needs rescuing until we get closer and realise that she is carrying a bag full of bread, which she scatters out for the gang of crows that is amassing at her feet.

Sharp bullets of hail shoot down from the sky, and we leave the river path and ascend to the sturdy grey buildings of Inverleith Row in search of shelter. We find ourselves in the basement of Aurora Books, antique bookshop and binders, and we look through mid-twentieth-century books about remote Scottish islands with pleasingly patterned covers while the hailstorm rages around us. We are climbing in and out of different pockets of the city, avoiding the rush and the tourists that gather in its better-known vicinities.

Eventually the hail stops and the sun comes out. Back on the Leith path, we look over the edge of a bank and see a sleeping swan; the erratic weather conditions have imbued the air with a sense of foreboding, and we start worrying that the swan is dead until, eventually, it moves. As our journey resumes, the setting becomes increasingly ordinary as we pass through the areas between Inverleith and Leith. We go by council houses and industrial buildings both wrapped in ragged trees and ivy.

But eventually the water widens and the buildings grow again as we arrive in the centre of Leith. Modern concrete and glass structures glisten in the sunshine. Imposing buildings that would be more at home in the centre of Gothenburg line the water. Unlike the centre of Edinburgh, there are few people around and we pass deserted bars and cafes. By the water's edge is a noticeboard sadly devoid of notices; its lack of content is surrounded by a frame in the shape of a cruise liner. The peace is interrupted by another violent shower of hail, so we duck into an empty restaurant for shelter and sustenance.

NORTH BERWICK

Bass Rock

My memories of our afternoon in North Berwick have a distinct colour scheme: the rusty orange of the lichen and the deep dark brown of the rocks against the bright blue of the sea. They framed Bass Rock as we stood, looking out at it from the pier: the squat, square but somehow deeply iconic island firmly in our line of vision, with its proper lighthouse at its base.

The rock seemed to follow us around the town, as though it were orbiting the mainland. Even at a little park on a corner, off the High Street with no view of the water, there is a mural of the town with a two-dimensional Bass Rock in the centre of the painted sea.

I know the form of the island is going to dominate my art-work from that afternoon, and when I sit down to draw from my memories in ink, it comes out far more graphic and stylised than I had intended. I draw striped lines and flat, coloured

planes. Looking back through my photos I remember the outdoor swimming pool on the beach, large and geometric, like a pentagram with straight sides, mirroring the silhouette of Bass Rock across the Firth of Forth. The thickening clouds and the tops of rooftops of the town reflect crisply in the water.

We'd walked up North Berwick Law and the gorse was abundant. It was soft and rounded, echoing the similarly coloured lichen on the rocks out on the pier. As we climbed, the surrounding countryside grew clearer, ploughed fields making gratifying defined planes, unfolding as our distance to them increased. To climb up you have to wind around the hill, reaching a ruined chapel just before finding the fibreglass whale bone at the top. Through gaps in the ruins, and every way you turn out to the sea, Bass Rock sits, constant like a guiding star.

ORKNEY

Drystone Walls and Ancient Dwellings

FINDING FOCUS

The bus drops us off on the outskirts of Stromness. We walk in past the ferry terminal, the busy patterns of a working harbour: bright rectangles of primary colours against the white of boats, punctuated by orange circles of buoys. This is in contrast to the town we are entering. I have seen many photos of Stromness, looking into it from a boat on the water: a pretty arrangement of houses and pier-side gardens leading onto the sea and rising up the slope behind. Because of the way the town is built, with private houses actually on the water's edge, once you walk into the high street you cannot see the rest of the town.

You are in a narrow street of austere grey buildings running parallel to the water. Gaps between houses create narrow bottle-shaped frames of deep blue sea and a slice of textured green and brightly coloured boat shapes. Aside from these, being in the town feels austere and slightly claustrophobic.

While many of the shops are selling thrown pots and other local crafts, there is nothing twee about this town. Looking up the hill into the maze of paths, gardens and lead-coloured cottages, it's an extension of the unforgivingly bleak landscape we saw as we drove across from Kirkwall. I wanted to come here as I had vague and

romantic notions of remoteness. I had known Orkney would be 'bleak', but I had not really considered the real implications of that word. This bleakness is created by the emptiness of the open plains combined with the unadorned grey stone houses, built to withstand storm and gale, and an almost complete absence of trees. On this island of extreme weather, there is no place for unnecessary adornment, whether manmade or natural. This absence makes me feel strange and exposed. I've nowhere to hide; I'm just a tiny figure on a vast, empty landscape. I feel anxious that I've made a mistake dragging me and Ross up here. There is nothing to see except nothing, and nothing pretty or colourful to distract me from my fears and woes. Just the screeching of sea birds and the rumble of fishing vessels.

We arrive at the Pier Arts Centre, and I'm flooded with relief to have something structured and specific to look at and experience. This gallery was founded as a permanent home for the collection of author and peace activist Margaret Gardiner, in 1979, and it includes works by major twentieth-century British artists.

We head up to where their permanent collection is displayed. It's funny how well the St Ives Group work fits into this place; the muted colours and geometric plainness of these paintings and sculptures, while generally not inspired by Orkney, seem to reverberate with the landscape and make sense of it. I come across the painting 'Lichen' by Ben Nicholson (1952). I'm drawn to it because of its name – being a lichen devotee – and

its small, perfect, geometric shape, so abstract but so clearly embodying the essence of the stuff.

Looking at all these renderings calms and focuses my brain. To me, any place is complex and multidimensional, infinitely more than just what it looks like. This is why abstract art, particularly of this period, resonates with me so strongly. It reaches beneath the surface of a place and visualises how it exists in the mind and emotions of the viewer.

I feel a greater sense of focus after leaving the gallery: I understand how to look at things more, to accept the starkness of the landscape and architecture and find my own visual patterns and connections. The further west down the high street we head, the more I relax. I trot down the passageways onto stone jetties that seem to be gardens of the sea, facing houses but without boundaries to keep the public out. We are able to look back across the town's sea-facing front, where washing lines hang and old buoys, driftwood and hardy plants in pots provide the only adornment. We come across a white-and-blue-painted hut featuring antlers, and an arrangement of round, striped stones carefully arranged on the top of a wall, like planets. The

Ben Nicholson painting 'Three Circles' (c. 1946–7), which we saw in the Pier Arts Centre, comes to mind. It featured a white, grey and black circle against a grey, textured background.

Walking out of town along the Ness Road towards the Point of Ness, the huddled architecture of the town dissipates into large, more widely spaced farm buildings. We soon find ourselves on the coastal path, looking out at the rounded mountains of Hoy, muted in the distance, arranged like giant beasts in repose. Fat, fluffy clouds lie low and numerous, arranged in an uncannily orderly fashion; it's as if I am underwater looking up at a fleet of fluffy galleons on the water's surface.

My eyes slowly become attuned to the rhythm of the environment as we walk further away from Stromness. We pass abandoned grey-stone Second World War bunkers, which are balanced on the scrubby grass that leads down to the black, jagged beach. The beach alternates

between long black strips of rock and areas of rounded stones. The drystone wall that divides the rather bleak-looking golf course, inland from the path, reflects this pattern: piled slates of brown rock, dappled with black-and-white circles of lichen. The thickness of the slates widens and becomes less uniform. Soon we come across a large stack sloping down towards

the beach, its lines horizontally made up of large flat areas of rock piled up against each other, sprinkled with gold-coloured lichen that glows in the sunshine. From an abandoned, concrete lookout point we admire The Old Man of Hoy. He stands imposingly in the distance across the water, guarded by the sleeping beast mountains.

STRANGE INTERIORS

Getting out of the car at the photography point at Yesnaby, the colours of the day hit our eyes; the almost desert-orange-brown of the ground strewn with broken stones, the stripe of deep blue sea. Rabbits hop around us before disappearing down holes. On a corner, we come across what might have been a dwelling: a circular-shaped construction made of piles of flat stones, topped with lumpy moss. Like the rabbits, Ross has already vanished through the little entrance at its base. I later learn that this building is in fact the Broch of Borwick. Brochs are particular to northwest Scotland and the Northern Isles, thought to be constructed between 600 BC and AD 100. There is a widespread belief that these structures were defences, but a theory that they served more to impress neighbours with their size and position has come to the fore.

The wall facing the sea has long since collapsed, so when I emerge from the tunnel-like doorway I find myself on a ledge. The walls still standing are grass topped and slope down to the ground, and stones from the missing wall are strewn around, so it almost looks like a natural hill from this side. While it's not an

interior, we feel as though we have passed through the entrance into our own private viewing platform. We see the deep blue Atlantic waters against the diagonal rocks that jut out from the bottom of the cliff. We sit and watch swooping seagulls, feeling oddly cosy in this exposed, windswept landscape.

Visiting neighbouring Skara Brae is a more official experience. A series of eight dwellings date from the late Neolithic period; it was inhabited for around 600 years, somewhere between 3200 and 2200 BC, and is one of Orkney's main tourist attractions. We pay our entrance fee and go to the visitors centre to see a recreated model of one of the dwellings. Plastic lobsters and crabs float on water in a dug-out stone bed on the floor: we learn that they kept shellfish in water tanks to keep fresh until they ate them. I am particularly struck by the plastic joints of meat resting on the stone sideboards; their shapes oddly echo the contours of the rocks on this coastline.

Outside, we follow a guided tour of American tourists around the site. These little homes, sunk into the ground, walled with stacked Caithness flagstone in a similar style to the broch, make a hilly landscape rather like a miniature golf course. It's complex and curving; I am delighted by how the soft, grassy contours shift as we walk, revealing new patterns and dwellings. The grass and the curves of the hills and the rounded corners of the houses create a sense of safety from the elements, and I am gratified by this human instinct to create such a snug environment in such extreme conditions.

On raised ground, further back from the site, is Skaill House: a seventeenth-century manor house belonging to a line of lairds of Breckness. It is grey and imposing, made up of sharp angles which make

it seem far less cosy than the Neolithic village. We pass the sunken garden, which similarly to Skara Brae has walls of stacked stone, but it is rectangular and, with a lack of bedded flowers, suggests an empty swimming pool. Inside the house, I admire the usual trappings: an intricate gold-leaf family tree, a cabinet of Staffordshire figurines, and am given a mild shock by a tiger rug lined with red velvet on the drawing room floor. I marvel at how very far from home this creature is and imagine well-bred ladies at their needlework, sitting on carved and ornate chairs while howling gales batter the house. And I then think of Neolithic families, sitting around a fire while lobsters swim around their home-made tank.

MAPS AND FLAMES

Among the rocks on the beach at the Brough of Birsay is a chunk of wall: neatly arranged bricks and cement, sliced like a piece of cake. As I step through the pebbles, I find a large flat stone of pale grey beneath my feet covered in complex swirls.

73

It reminds me of the gradation lines on an Ordnance Survey map and I gaze into it, searching for clues that will make sense of this strange and unforgiving island.

Beyond the rocks and stones at the back of the beach is a wide layer of seaweed that is a bright orangey red, like rust with the contrast turned up, deep and glowing. Its dry, twisting strands are flames made of paper, the vibrant depth of tone is in dramatic contrast to the shadowy palette of the rest of our surroundings, like a ring of fire guarding the ancient coastline against invaders.

The causeway to the Brough is a concrete walkway: thin and angular like a bolt of lightning. Its limited access gives the crossing a sense of solemnity, as if we are in a mystical children's story, off to retrieve a sacred object before time runs out.

The Brough has its own ring of seaweed flames, which we pass on our way up onto the raised, grey green, empty island, where the remains of a Viking village are nestled and embedded in its surface. Drystone walls about a foot high are covered in fluffy grass, making square craters with rounded corners. It's a maze of soft edges and layers with ancient stones emerging from hummocks of grass like grey teeth. On much of Orkney, the boundary between the manmade and the natural is often unclear, and here the two appear to have fused entirely.

Further into the island are the stone foundations of a twelfth-century Romanesque church; the highest part of the wall's remains come to about six feet high but the majority range from only a foot or

three, gradating like steps or piles of coins. These remains sit upon the grass and are more angular and purposeful than the village we've just walked among. We wander through the great empty chambers looking out at sea and sky, like ants wandering over architectural plans.

Leaving the village and church remains behind us, we head upwards to the lighthouse perched at the highest point of the Brough. Behind us the ruins make soft and satisfying patterns in the distance.

On our way back to Kirkwall we stop off at the Ring of Brodgar. Deep purple, blue and grey layers of land and sea surround us. Walking around this circle is like walking around the face of a giant clock. Each standing stone has its own individual character, several have distinctive profiles: a wide one with a proud brow and an imposing Roman nose, specked with orange lichen. Next along is a weedier, triangular fellow with a mop of grey-green moss hair.

I wonder why I seem so drawn to staring into the surfaces of the rocks here, whether its drystone walls, beach pebbles or ancient standing stones. We pay our respects to these kindly seeming ancient people before heading back to the car.

WESTRAY

The Redemptive Power of Puffins

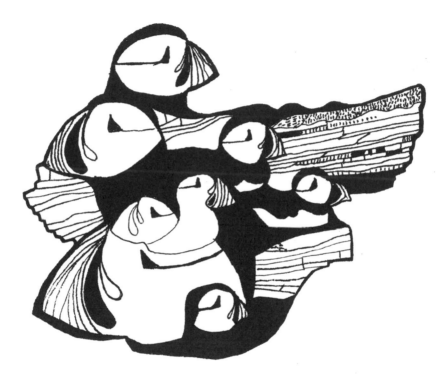

There is something so silly and self-absorbed about the way humans travel as a leisure pursuit. We ask what the place can give us, what it can tell us; we walk and we look, expecting the world to enrich us and create meaningful experiences. Yet this remote, windy, deathly grey island refuses to give. It's just there, solid, old and weather-beaten.

We are standing in the churchyard of the Lady Kirk in Pierowall, the main village on Westray, in the howling wind. Rows of tombstones and the remaining walls of the old church are the same unforgiving shade of grey as the rest of the village, a grey that takes on an insidious bleakness when not warmed by sunshine. Westray has a population of 600 and is known as 'Queen of

the Isles'. I'm not sure what we had expected, but after a rough ferry crossing and a rickety bus ride across the island, we find ourselves somewhere greyer and colder than Orkney. I feel guilty for dragging Ross here.

Most of the church remains date from the 1600s, but the foundations are medieval in origin, and it feels so old and so dead here. Many of the dark grey tombstones are covered in white moss, which incongruously suggests the coat of a hyena or a leopard. I realise how many of the names are Stevenson. I am not aware of having any Orcadian ancestry, but I find this deeply satisfying. My alienation momentarily melts away.

This connection doesn't sustain us for long as we walk along the coastline; maybe it's the grey, but there is a fierce raggedness to the rocks and the coast, making the mainland seem hospitable by comparison. It's as if now I've finally got my head and my mind's eye around the landscape of Orkney, once again I am being pushed out of my comfort zone.

The sea stack Castle o'Burrian is known to be the best place to see puffins in the Orkneys. Normally we would be likely to see them at this time of year, but

it has been a late spring and we know that our chances are slimmer. We have heard rumours that they've begun to arrive, but we daren't get our hopes up.

Bird watching is a strange activity – like any wildlife spotting, it relies on the assumption that the animal world will turn up for our pleasure. We migrate to these remote places to wait for migrating birds, who make perilous journeys purely for survival. On arrival, the sea stack is clearly devoid of puffins.

But then, as we sit on a rock peering through binoculars at the sea, we spot a group of them, quite far out, bobbing along in groups. Puffins come to shore between April and August to breed, and spend the rest of the year out at sea, so for the puffins their time on Westray is the least remote part of their year. As we sit watching them, and as we make our way back to Pierowall, the place feels less hostile. But perhaps it is the late afternoon sun.

We wait for the ferry home, sitting in a cafe that an Orkney resident has made in his living room. He is from Yorkshire and is a heavy metal DJ, and he tells us how he met his wife photographing puffins and fell in love and decided to stay. He goes to the mainland sometimes to see heavy metal bands play in Kirkwall.

KIRKCUDBRIGHT

An Artist's Town

After winding down country lanes for several hours, through the tall, green hills of Dumfries and Galloway, I alight from the little bus at the harbour in Kirkcudbright. I make my way onto the High Street, passing rows of terraced cottages, their surfaces a mixture of large, uneven brown stones left bare or painted over in tasteful pastels, and I reach my home for the night: The Greengate.

This white cottage, with a bright turquoise door and window frames, was the home of Jessie M. King: artist, illustrator and designer of pottery and jewellery, and a member of the Glasgow Girls. She is one of my heroes – I have always been captivated by her delicate and dreamy take on art nouveau. She and her husband, artist E.A. Taylor, lived in this house from 1915 until her death in 1949. They let the rows of artist studio cottages to friends and students as part of a summer school, creating an artist's commune environment in this sleepy fishing town.

This house is now a B&B, and in the upstairs sitting room I leaf through books about Jessie. I am struck by a photo of her dressed as St Margaret of Scotland: in long robes and a crown, looking like the stylised figures on one of her embossed book covers. I read about how she used to sweep around Kirkcudbright in floating black dresses and chunky beads: quite the local eccentric. There is also a reproduction of an illustrated guide to Kirkcudbright, illustrated and lettered by Jessie, the buildings of the town outlined in her signature gently wavy line, which is perfect for the soft lumpiness of the town's stone cottages. It's as if she drew the place into existence. Following a passageway to the right of The

Greengate's front door, you come out into an alley which contains the artist studio cottages. On your right, a sheltered area features pieces of driftwood and an old oak table, on top of which are shells and a basketful of beach flotsam, arranged purposefully like a drawing room. I make my way down the row of cottages, the wavy,

white walls punctuated with smooth, pastel front doors. At the bottom of the garden is a circular lawn, which I cross. I go through an arch to find myself in a cheerfully overgrown garden-wilderness. A peculiar stone statue of a soldier is nestled among the bluebells, the front of a shed frames the chaos through its empty window and, at the end of the garden, I discover a small sailing boat, run ashore, enveloped by weeds and plants. The international flags on its backstay are caught up in branches. This garden and the driftwood/oak table arrangement are the creations of Colin Saul, who owns The Greengate with his wife, artist Pauline Saul. Finding this agreeable chaos hidden just behind the calm, defined quality of the house's front seems to me an apt summation of the life of a graphic artist: the tangled chaos of everyday life lurking just behind the elegance of perfectly judged lines and compositions of their creations.

The first stop on my tour of the town is the Tolbooth Art Centre, which is just a couple of doors away from The Greengate on the corner of the street. It's an imposing seventeenth-century building of brown stone. The former town council offices, burgh council and prison, it features an impressive steeple: a weathervane perches on top of the central spire flanked by two shorter ones, which strikes me as mildly demonic. On an information board, I read that beneath this steeple used to be the site of the building's prison cell, which once housed Elspeth McEwen before she was burnt at the stake for witchcraft in 1698. This makes me think of Jessie,

sweeping around the town in her black robes, creating detailed, dreamy worlds on paper and out of metal. Inside is a painting of 'Jake', as Jessie was known to her friends, her grey hair piled on top of her head, clad in dark silks broken up by technicolour scarves, like exotic yet ragged bird feathers.

The centre also features an exhibition of paintings of flowers by local artists. Behind a display of brightly coloured floral oils, propped up on easels on a yellow tablecloth, is a panel by Jessie M. King. It depicts St Andrew against a mountainous landscape, with a harp-wielding angel shining golden beams down on him. Thistles and thorns intertwine around the scene and the figure wields a large shield bearing the blue cross of the Scottish flag. The image is made of large planes of flat colour, and it has a more solid and purposeful quality than much of her work.

I walk past the stately crags of the ruined castle on my way to The Stewartry Museum. Inside, it seems like a typical rural museum of taxidermy and war medals, but among the glass cases of

ceramic bottles of shaving cream and local pottery are cases of Jessie M. King's work, with small, typed information cards in the same style as the other exhibits, creating a certain democracy to the display. The mugs depicting Queen Victoria or commemorating the coronation of Edward VIII sit harmoniously alongside King's ceramics.

Her painted ceramics, featuring figures of children among patterns of petals, have a lightness, as if they were being blown in a gentle Scottish breeze and just happened to land in a stylised formation.

I wander round and admire First World War medals, the colours of their ribbons combining to create satisfyingly abstract patterns. A case contains early eighteenth-century lace and a collection of bobbins. I look at a pipe carved into the shape of a fox and Victorian beaded jewellery and purses. While not the work of professional artists, they are as beautiful and covetable in their own way as the work of Jessie. I finish my visit by admiring a rather moth-eaten taxidermy puffin, thinking of seeing them jumping around on the waves off Westray days earlier.

Back to the High Street and to Broughton House, the pink-and-light-blue former home of E.A. Hornel. It stands proud and detached, pink paint over its uneven surface like cake icing. E.A. Hornel was a landscape and portrait painter who associated himself with the Glasgow Boys. He lived in Broughton House, with his sister Elizabeth, from 1901 until his death in 1933. I wander through the grand rooms, becoming absorbed by the lavishly

patterned rugs and Japanese artefacts that create an ambience of Edwardian decadence: a heavier and more self-important atmosphere than that of Jessie's world. On the stairs, I notice traditional embroidery samplers created by Hornel's sister, one of which depicts a house much like Broughton House but simplified into the geometric squares of sampler embroidery; rows of stylised, identical trees stand around it. I find this oddly soothing.

It's only when I step into the back garden that I feel a returned connection to what I've come to Kirkcudbright in search of. The garden is heavily influenced by Japanese gardens, soft and enchanting but with a structured, designed quality. It's one of those gardens that contains many different enclaves which multiply each time you look out from a new angle. Then I find a cat, who follows me around, hopping over stepping stones, her gold and black patches look attractive against the lichen and ferns of the rock garden. I squint and the scene becomes a decorative pattern, perfect for the surface of a mug or a bowl.

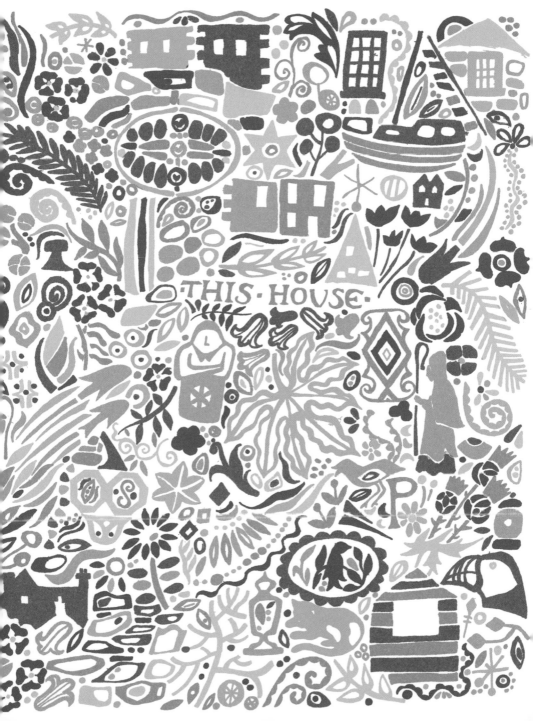

MARGATE

Surrounded by Shells

I sit down to draw from my memories of being inside Margate's Shell Grotto. I had been meaning to visit it for years. The idea of a mysterious underground chamber decorated with shells forming esoteric symbols seemed like my dream tourist destination. The grotto, whose origins and purpose are subject to much speculation, is made up of a winding, underground passageway covered in a decorative mosaic which meets a cavernous room known as the 'alter chamber', where the shells form cryptic formations that seem heavy with significance.

While I was impressed by the obsessive detail of the shell mosaic, I also found it ugly and creepy. Soon after the grotto's discovery in the 1830s it opened as a tourist attraction. Nearly 100 years of gas lamps have stained the walls a dirty brownish grey. The grotto has a dinginess; there is the unsavoury feel of rot as you look into the carefully arranged flower motifs. The shells' colour conjures the smell of petrol and gives a chemical headache. Later on, standing on the pier, I see a more diluted version of the colours in the sea, brown waves crashing onto grey sand, the roar of motorcycle engines in my ears. I see it again in Arlington House, which towers over the town as you reach the station.

It was cramped inside the grotto and quite full of tourists. Odin, my friend Amee's nine-year-old son, raced around corners excitedly. I most enjoyed the panels that evoke fertility symbols. One motif had the distinct suggestion of a reproductive diagram: cockle shells placed alongside each other in winding arms coming off a central body. I saw a couple of panels that reminded me of faded African textiles, the plainer, understated cloth of the Yoruba people. Something about the surface of the shells made me uncomfortable. I kept imagining my skin pressing against it and the ugly imprints it would make. I was happy to be out in the gift shop, helping Odin choose gemstones to buy and take home for his treasure box.

When I draw, the shells come out tiny and delicate. I fill the areas around them in black. Loose patterns begin to form, echoing motifs from the grotto, but they are a stylised constellation. It's like looking up into the night sky and seeing these strange patterns of fertility, but, unlike in the awkward tunnels of the grotto, you can stare past them into eternity.

GLASGOW

Women's Hidden Histories

I'm standing facing Mercat Cross in Glasgow's East End, listening to the Glasgow Women's Library's East End Women's Heritage Walk audio tour. Mercat Cross is shaped like a castle turret, and was designed by female architect Edith Burnett Hughes in 1930. I stare up at the silhouette of the unicorn that perches on top of the cross, before following the instructions to move my gaze over to the Tolbooth Steeple: a round, bright blue clock face sits at the top of the building before the steeple disappears into a Gothic spike. My narrator tells me of disreputable women in the sixteenth century who were held in shackles in the tolbooth. This was the last recorded period of witch-hunts, where suspected women were tied up and weighted and thrown in the river to the sound of drums and chants.

In 1917, a vast protest took place here by the Women's Peace Crusade, but it was largely boycotted by the press for being unpatriotic, so no photographs exist. In this age where everything is photographed, I enjoy the idea of this huge event existing only in memory. I visualise a lively, Technicolor protest projected over this large, flat expanse of grey and green. This is something I will do often on this walk – not so much seeing ghosts as visual echoes of women's struggles in this great city, which in certain lights come into focus before fading into the everyday.

Wandering around the People's Palace, a museum celebrating the daily life of the people of Glasgow, I come across a case of tiny dresses in undyed rough cotton and others in pale blue-and-white stripes. I read that these are clothes for infants who were in prison with their mothers and I find tears welling up. I go back outside to gulp muggy Glasgow air on the green.

I continue over to Templeton's Carpet Factory. It is large and imposing, its front elevation looking like a decorated carpet itself. I am a sucker for a highly ornamental building, and indeed this one, designed by William Leiper, was modelled on the Doge's Palace in Venice. But the voice in my ears soon interrupts my superficial admiration of its pleasing aesthetic by leading me to Templeton Gate: a memorial for female weavers who died working here. The invention of power looms meant these factories were full of women and girls, often as young as nine or ten. In 1889, part of the wall collapsed, killing 29 women and severely injuring many other female workers. The factory supplied carpets to the White House and the Taj Mahal, made by the hands of children working in dangerous conditions for terrible pay; like much of what we buy on the High Street.

The factory is now a business and retail centre, and part of it is a German craft brewery, run by a woman.

Back out and mildly fuzzy-headed, I stare across at the rows of metal poles, looking like truncated hat stands, spaced evenly across the grass. This is a memorial to the drying greens, where women have been coming to wash clothes for centuries; many of these drying poles are Victorian. The spindly spaced-out poles look like unfinished foundations, or the bare bones of a memory or history.

I make my way past the stout, beehive-roofed, Victorian 'Logan and Johnson School of Domestic Economy' and the former site of the Singer Sewing Machine Factory, and eventually arrive at the Glasgow Women's Library. Founded in 1991, it began with materials relating to the arts organisation Women in Profile from Glasgow's year as European City of Culture in 1990. I wander in and immediately feel a sense of supportive peace and inclusion. I browse its collection, chat to the delightful staff and admire a case of suffragette

memorabilia. It feels good to visit the 'home' of the disembodied voice who is accompanying me around the East End.

I am led to Bridgeton Cross, the heart of the East End weaving village, and towards the Old Calton Burial Ground where six male weavers were buried. They were killed by soldiers in 1787, in what was possibly Glasgow's first ever industrial dispute.

Down the unassuming Bain Street towards the Barras, you pass a blue plaque outside a shop front. It commemorates Betty McAllister – 'Battling Betty' – seafood shop owner and community activist, who fought for the rights and living and working conditions of the poor in this area. Then to Gallowgate, where the unlit lights and stars of the Barrowland Ballroom stand pale pink and blue on the grey concrete, grid-like structure. The venue was opened by Maggie McIver: 'Queen of the Barras'. I feel the force of these two powerful women in these run-down but lively streets.

Nearing my starting point I get to the Saracen Head pub. It is closed but is said to house the skull of a witch, Maggie Wall, who was said to have been noted in a Perthshire memorial of burnt witches.

There is apparently little historical evidence to support that her burning ever took place, or that this woman ever really existed, but the legend's presence embodies the memory of murdered witches which is such a prevailing part of the history of this place, of its women's and its human history, and it seems apt that this walk starts and ends with tales of these clever and independent women murdered by frightened citizens.

Back at Mercat Cross, the tour ends with the tale of St Thenew's cult: the legend of the daughter of a Northumbrian king, who was raped and thrown off a mountain but survived, and later gave birth to St Mungo, the founding father of Glasgow. A tree near her chapel might have been a place where women went to make offerings, metal shapes of body parts for help with their pregnancies. Her cult died after the reformation. St Enoch's Church stands in the chapel's place: St Enoch is a corruption of Thenew. Historian Elspeth King called this 'the Thenew factor': how women are so easily written out of history. But on this walk, the history of women that pulses through this city is illuminated.

OXFORD

Finding Calm in Common Ground

When you enter the gate at Port Meadow, the view that meets you is not spectacular: just miles of flat grassland with cows and horses grazing in the distance. Due to recent storms, there is a large area of flooding on the grass reflecting the ominous thunderclouds, blurring the definition between sky and land. It is the day after the EU referendum result. The world seems to have turned upside down, but as I walk out into the meadow, the jangling in my brain lifts and dissipates, evaporating like steam above the flooded grass. I have my newly rescued Staffordshire bull terrier with me. It is Ada's first trip out of London and she leaps and races with joy in this open landscape, mirroring the improvement in my spirits.

Managed, natural land within a city has a certain type of power. I've had similar experiences on Hampstead Heath or Richmond Park in London in times of seemingly insurmountable distress. These places are pockets of calm and sanity within a stressful environment, a place not serving any purpose for

its animal and human inhabitants other than just being. Port Meadow is said to exist because in the tenth century, the Freemen of Oxford were given the 300 acres of pasture by Alfred the Great as a reward for helping to defend the kingdom against the Danes. This was recorded in the Domesday Book, and perhaps it is the sanctity of this land as pasture, which has been observed for over 1,000 years, that gives this place its strong sense of peace. It's raining as we walk along the river's edge, but sheltering under trees I feel safer than I have done in days.

Two months later I am back here with a friend who recently moved to Oxford. It is a roasting day and we swim in cool water, while horses graze lazily on the riverbank. Katie's spaniel swims alongside us while Ada keeps guard on the water's edge. Again this simple area of grazing land is providing relief from the discomfort of urban life. It is the first time I've ever swum in the Thames and being in the same body of water I grew up beside, 60 miles upriver, is an agreeable thought. I reflect that rivers are lines across the country that connect and bond us, and will continue to do so long into the future.

CAMBRIDGE TO ELY

River Cam

Walking along the path of the River Cam, edging along Midsummer Common, young horse chestnut trees form round leafy spheres that almost seem to float on the intricately textured surface of nettles and long grass. Muted mid-green permeates the scene, areas of shadow provide subtle tonal variations. On the other side of a footbridge is a pub with a garden, which nestles up against the river. As I sit there sipping my shandy, a young man asks me if this is where the May Bumps rowing race begins.

Continuing along the river path, the landscape across the water is a combination of pylons with hazy meadows and the odd pony, lazily munching on long grass. I realise there is some sort of serious rowing event occurring around me; there is the increasing quantity of young men and women in mysterious unitards and I am frequently almost mown over by hearty undergraduates on bikes shouting into megaphones. The crowds of milling people thicken and, on either side of the river, groups of leisurely spectators gather

around gazebos and temporarily set-up bars and cafes.

I stroll through this purposeful, celebratory environment feeling like a ghost, entirely disconnected from their shared sense of enthusiasm. A sort of alienation that organised sport always triggers in me takes hold, and I wish I could be truly alone. At the A14 bridge, racers get into their boats, the gun fires and they are off. This dramatic start marks the true beginning of my own voyage too. I walk in the opposite direction, heading into the heart of the fens.

Now the shouting cyclists have melted away, I'm surrounded by willows looking out onto flat green fields, the green haziness punctuated by graphic structures of cow parsley. I meet a wide oak tree trunk, almost entirely overgrown with elderflower. It looks dramatic and pagan and oddly alive, like a wise spirit of the fens encouraging me on my lonely journey. I continue past thick green-and-white elderflower hedges and become fascinated by the berries; they seem so significant and precise, like delicate atomic models.

As I pass Bate Bites Lock, the barges that line the river gradually become more run-down and eccentric, signifying my increasing distance from polite society. The trees on the riverside thicken on the other side of the lock, enclosing me in a thickly fecund tunnel of gently bobbing willow and elder that make a wall of varying muted greens and subtly different patterns of the different leaf structures. The water is dotted with willow seed and the air is thick with it, creating a muffled feeling, like I'm looking through smoke or smeared glass at my surroundings. While on paper, this should be an idyllic rural scene, there is sinister heaviness to it, as if I am being suffocated by it.

After a brief sojourn inland to Waterbeach and through the manicured river path of its marina, I find myself out on an overgrown riverbank path, in a neck-high jungle of long grass, cow parsley and lady's bedstraw, which glow brightly through the grasses and nettles as if lit up from within. I battle through them, ripped and stung, peering out over the top at the greenery. Before nineteenth-century agricultural drainage systems, the low-lying fens were often flooded and farming was limited. This landscape is now ordered and tamed below the tangle of wildflowers; you can see this in the precise right-angled turnings

of tributaries off the river, yet it seems to have a power or a hunger, a remoteness from warmth and humanity, that one would associate with a wilder landscape, as though the essence of the inhospitable flood land is still present, creeping up through its managed facade.

I notice bright blue flashes among the muted foliage and I realise they are tiny dragonflies, and their flitting brilliance will follow me all the way to Ely. A larger one settles on a branch and I creep up and stare at its monstrous, prehistoric head, which resembles a robotic dinosaur. The jungle of weeds disperses to reveal a clearing of twisted dead hawthorn trees like a meeting place for monsters.

The path is often now higher than the water and the landscape on either side of the river becomes more agricultural. I walk past the same, vast field on my right for over a mile; mustard-yellow patches of grass make subtle patterned lines on deep maroon soil, with paler stripes diagonally across it, like inverse shadows, this gradually gradating to neat little rows of bright green shoots. On the other side, black soil lines miles of bright green leaves. The image of these orderly fields etches itself more strongly into my visual memory than the chaos of the path, creating patterns of ragged, organic forms in endless rows under overcast skies, interspersed with the electric blue of the dragonflies.

Below me the top of a white pick-up peeps over the grassy bank, as if it's spying on me. I've not seen a human soul for miles. I come to a Second World War pillbox, squat, with spiky grass growing on its top like a punk owl. My urge to anthropomorphise inanimate structures is strong on this walk, perhaps because I feel so isolated. In Cambridge I longed for solitude, but here my seclusion begins to feel threatening.

Eventually, the River Cam becomes the River Great Ouse. I continue along and the nettle jungle is back, less forgiving than ever. I'm walking along a high bank and, as I look out, I see the distant shape of Ely Cathedral stately and tall. It seems to drift across the horizon line like a large battleship in the distance, and when I look away from it momentarily, then look up again, it has shifted position. The flatness of the land, the slow winding of the river and my exhaustion warp my perception of dimension and distance. I become fixated by the cathedral, but it grows no nearer. A group of cows gather around me and I'm terrified. As I plough on, the sky is beginning to darken.

BEAULIEU TO BUCKLER'S HARD

Looking for Damerosehay

Driving to Beaulieu across the heathland of the New Forest, it is overcast, almost misty. Wild ponies gather in small groups, pale in the distance. The shelter and soft grasses of the heath lack the drama of moorland, but it has a lovely gentle and understated wildness to it, created by the shaggy edges of the ferns and heather over the lumpy mounds of grass.

We have come to this corner of England in search of *The Eliots of Damerosehay*, a trilogy of novels by Elizabeth Goudge, written between 1931 and 1951, about a family overseen by a wise and charismatic matriarch: Lucilla Eliot. The family home, Damerosehay, is nestled off the River Beaulieu. The family saga unfolds over the three volumes, as dramas erupt and are then resolved, but the aspect of the book that most inspires my devotion is the setting. Goudge conjures the most haunting atmosphere: somewhere alive with feeling and goodness, where buildings have souls and revelatory visions occur in woodland clearings…

*

After tea he had gone out into the garden quite by himself and had seen how the old red walls were built all around him to keep him safe. It had been cool in the garden and the daffodils had made pools of gold beside the

grass paths. There had been no sound except for the far-off murmur of the sea and the blackbird singing in the ilex tree. He had known for certain that no one would ever quarrel here.

*

The houses themselves are fictional and the names of the places are changed. After some investigation, I found that the villages of Beaulieu and Buckler's Hard, and the surrounding countryside, are thought to match the settings of the book the most accurately. Rationally, I know that the books are set only in a world of Elizabeth Goudge's imagination, which used this environment only as a springboard. However, it has been a gloomy June so far – the UK has just voted to leave the EU, triggering horrifying acts of racist violence across our country. In Goudge's books, Damerosehay was always a sanctuary for its inhabitants, so for me it is apt to be making our pilgrimage here today.

Once at Beaulieu, we walk past terraced cottages of Georgian soft orange brick on our way to the path that will lead us to Buckler's Hard. It's pretty and well-preserved, one of those well-looked-after villages that is appealing yet museum-like in its perfection. There appears to be no pub, suggesting a lack of heart to the place.

On the lane leading to the fields are three golden cows reclining on the ground. Their coats match the colour scheme of the village perfectly and Ada, who has never met cows before, is wide-eyed, awed but

respectful, as we pass. Before reaching the path that leads through the nature reserve, we pass a restored cottage partially hidden by trees. It looks too modest to be Damerosehay, but the way it is nestled so closely into its leafy surroundings chimes with the spirit of the books we are chasing.

Winding along the path through the marshes, we are enclosed by oak and beech. We peep out through clear patches at the river, dotted with smart speed boats. There is a freshness and lushness to our surroundings. The wooden boardwalk leads over little islands within the marshes creating a childlike sense of adventure as we weave around them. Below our feet are patches of star moss partially covered by ferns, and we delightedly discover a tree root edging our path, expanding to a lumpy knot, covered in moss with leaf shoots erupting from it. It looks like nature has tried to create a semi-relief impression of a standing tree in full bloom, and the accidental playfulness of it is for that moment an incredible tonic to the grimness of the human world.

When you reach Buckler's Hard, you meet a shipyard – not the old working shipyard alluded to in Goudge's novels, populated by gruff sea dogs and where ships for Nelson's fleet were once constructed, but a functional, clean place where small yachts and leisure crafts perch primly, held up by sticks on the gravel. As we approach the village, there is a quaint and unusual dwelling on our right: a toy-like cottage featuring arched red window frames and a fringe of low-hung thatch. This turns out to be The Duke's Bath

House, built by the Third Duke of Montagu for his son to bathe in. Its unusual allure fleetingly connects to the otherworldliness we are seeking.

We sit outside The Master Builder's hotel, on the wide lawn that leads down to the water's edge that makes up the bulk of the hamlet. The openness of the scene is pleasant; after being deep in the marshy woods, the simple cottages that line either side of the green are undeniably delightful. In the past, this place must have felt very remote and cut off from the rest of the world. But the sense of being in an outdoor museum pervades, at odds with the mysterious and hidden version of this place that exists in our minds. In spite of this, we feel restored by our quest, however futile. In looking for somewhere that doesn't really exist we have re-tuned our eyes to finding enchantment and beauty in our surroundings.

PATTERDALE

A Tribute to Topsy

Sitting in the sunshine outside the Patterdale Hotel, with a half of ale, I draw the shapes of the slate wall, the stones cosily nestled together. On the next page in my Moleskine notebook, I fill the negative space around them creating a pleasingly defined pattern on the page. Although I've been drawing the surface of a wall, not the green backdrop, there is a quality to the drawing that seems to encapsulate the visual essence of all our surroundings.

I had my reservations about visiting the Lake District; I often find heavily documented and celebrated destinations alienating and underwhelming. There are too many pre-existing ideas about how you are supposed to experience it and this tends to leave me numb. But as our little single-decker bus rolled through the fells, and Ullswater glimmered through the trees, with towering green slopes around it, my mood lifted immeasurably. When you fall in love with a location, a connection or recognition occurs. To me, the Lake District resembles an imaginary land formed by illustrated children's books and films I inhaled as a child.

Our base for various walks was chosen in homage to our late Patterdale terrier, Topsy. Her highly individual character is now the stuff of legend and we'd always talked about coming to her ancestral home. And it is a tiny hamlet on the bottom edge of a lake, fringed by slopes and the ubiquitous fields of sheep. The village shop sells Patterdale terrier mugs and tea towels, much to our delight. We spot five Patterdales over our visit, and we imagine the little black shape of Topsy running over the hills. Simple slate or whitewashed farmhouses nestle under wide, seemingly vertical, fells, which are covered in a coat of ferns that gently ripples like a feather boa.

The following day, we are sitting on the other side of the lake admiring the tufted islands dotted on the water, like mini

inverse versions of the lake. The mountaintops were islands themselves millions of years ago, when this part of the UK was underwater. We ruminate on how we entirely understand why all the Romantics found this landscape a revelation; the sharp angles of the hills and mountains create a sense of drama that is then softened by the lushness and rounded shapes of the greenery. It is a powerful combination. I long to see this view in every season.

On the way up to Raven Crag, we pass Glenridding houses where the front gardens are full of rotting carpet – the ground floors ruined from December's flooding. I feel so sad for this cheerful waterside village as we wind our way up the slope, into the trees beyond.

Soon we are encased in a soft world of green moss-covered trunks under a canopy of oak leaves; the bright pink of foxgloves provides flashes of colour. An old oak sits at the centre of this leafy cave, its roots lumpen and huge like a miniature mountain bursting up from under the ground. In this sort of landscape it's so easy to see your surroundings as a series of dramatic vistas, peaks against the sky. Yet it also contains beautiful inner worlds. As we continue upwards, the trees part and the wavy shape of the lake is revealed, perfectly framed by branches. Soon we are high enough to see mountains, the rich greenery gradually disperses to reveal a map-like pattern of overlapping browns and oranges.

The next day we walk down the valley with Goldrill Beck winding through its base. Our path is raised from the bottom of the valley, and we are walking parallel to the beck. The slope is thick with ferns, rich and green, and I keep starting at the shape of the mountains ahead of me. I stare up at them and there is a ridge or a crease creating a shadow on the green, textured mass. Looking ahead, the steep slope we are skirting cuts the view diagonally. I see very high peaks in the distance that shift as the path gradually turns. But I know that these mountains are kind somehow, or maybe it's just that they are swathed in thick green.

Down at Low Hartsop we walk along the road; the drystone wall is covered in Rambling Rector.

LEVENS HALL

Living and Breathing History

My memories of Levens Hall's gardens are confused. I find it impossible to retrace my steps around the grounds in a logical progression. Instead, I recall it as a series of images: different arrangements of lumpy topiary giants gathered like an alien army; flashes of red *Tropaeolum speciosum* adorning the surface of giant box hedges; the straight lines of hollyhocks planted like perfectly spaced flames.

I'd imagined the topiary garden would be more elegant in appearance. I was not expecting the mass of surreal creatures that now surrounded me. Most are globular, lopsided, like bubbling slime in suspended animation or unevenly risen rock cakes. A deflated Michelin man sits alongside a giant frog's head, its mouth hanging open. I am delighted that none of the irregularity is down to shoddy workmanship or neglect. They are all based on specific designs and are perfectly tended in their oddness. The contrast with the chilly, grey dignity of the main house's exterior highlights the playfulness of this controlled madness.

Walking around the gardens entirely warps your sense of scale, too. Depending on which part you are in, you shrink and grow accordingly. In the seventeenth-century garden, two-foot-high obelisks stand in a circle, but turn a corner and you are towered over by giant yew chess pieces, a King and Queen, and are miniature once again.

The comical shapes of the garden are made sense of and framed by the regimented rows of planted flowers. Hollyhocks in colour-coordinated rows planted in perfect triangular beds focus the eyes and stop the garden feeling too inelegant or clumsy.

Levens Hall was acquired in 1688 by a wealthy courtier of James II. The garden was the vision of Frenchman Guillaume Beaumont (former gardener to James II) and was laid out formally, influenced by the Dutch style of the period. Garden fashions soon changed to a more natural style, and all other British Beaumont gardens were redesigned. It is thought that this did not occur at Levens Hall due to a lack of fashion-conscious male heirs. This happy irregularity has meant that Beaumont's garden design is still with us today.

Wandering around a garden preserved in its original form more palpably connects us to history than admiring an old building. It enables us to step inside a three-dimensional, living and breathing embodiment of the tastes and aesthetic ideas of a specific era.

NINE STANDARD RIGG

The View from the Dinosaur's Back

·

We follow the path out of the village of Nateby, up into the hills; our eventual destination Nine Standards Rigg. It is the hottest day of the year so far, and the fields and deep green trees around us emit an almost tropical, liquid warmth. There is a lack of romance to the scene, but the path is slowly getting higher. We pass a working quarry, and the hills beyond start to peep over the edge of our line of vision. Our immediate surroundings become increasingly craggy, the grass is rougher and bleached out by sun, and drystone walls replace hedges.

As we climb Hartley Fell, my eyes are drawn to beyond the immediate hillside out over the North Pennines. After my recent walks in the heart of the Lake District, where dramatic fells sprouted up all around me, my eyes relish being able to see far away. I gaze at what Rebecca Solnit describes as 'the blue of distance': that muted hinterland, where a deep but faded blue infuses the shapes of mountains, hills and fields at the furthest points and they are reduced to tiny patterns, like the surface of a pebble.

Cumulus clouds are low-hanging, suspended in evenly spaced rows. From this distance it's as if they are only a few millimetres from the horizon, and they spread above it in a soft layer that mirrors the hills in form and scale. They cast large shadows over the folds of the landscape like translucent layers of ink overlapping solid colours on a screen print.

Nearing our destination, the landscape becomes craggier. The limestone is loose underfoot, and hardy sheep clamber around us. The purpose of the Nine Standards is unknown,

although it is speculated that they mark the boundary between Westmorland and Swaledale. They stand along the ridge of the fell: some are lumpy mounds of stone in an almost beehive formation, while others have a more designed structure which oddly reminds me of the topiary yew trees we saw yesterday at Levens Hall. The ground around them is strewn with rock. It is as if we are eating our sandwiches along the spine of a dinosaur. We can see out over fells from every direction: the North Pennines and Lakeland fells, and also now the Yorkshire Dales and the Howgills.

It is becoming almost unbearably hot as we begin our descent; the clouds dispand and the rock and grass begin to take on an almost hallucinogenic quality. Walking towards a view feels very different to walking away from it. When ascending a hill or mountain, it is as if you are creating the scene in your wake as you walk, every step upwards crystallises the view you stop to look back at and admire. Whereas walking downhill is almost walking into it; the form of the scene gradually melts away and dissolves before it is reached.

As we reach the lower part of the fell, we run out of water and struggle to keep going. We take a different route, heading towards a distinctively rounded and striped mound that we could see on our ascent. At its base is a wildflower meadow. Its fine, detailed texture practically crackles in the heat against the rich green of its hill, and I can almost feel the blades of long grass tickling my skin, just looking at it. At the end of the meadow, we reach a stream, and gulp heedlessly and thirstily from it.

KIRKBY STEPHEN TO SKIPTON

The Yorkshire Dales by Train

I'm somewhere near Helwith Bridge on the Settle–Carlisle Railway, and the train hasn't moved for the past half hour. A signal box was hit by lightning in the thunderstorm earlier this morning, so my journey through the Yorkshire Dales is halting and slow. In my notebook I've drawn a geometric landscape, like a modernist island in black fineliner, separated into planes with lines, the edges of which are curved but meet at sharp angles. I begin to fill the shapes with lines and patterns.

This drawing, while abstracted, captures my general impression of the form of the Dales that I saw out of the window while we were still moving. Long fells and wide steep fields cut across with drystone walls, like seams on fabric, wound past me. Being on even a slowly moving train, I was less able to capture or memorise shapes of specific hill formations, but

instead I passed through these dramatic limestone valleys, shaped thousands of years ago by glaciers, and I watched their elegant shapes unravel through the glass. On the Ribblehead Viaduct, we rose high with panoramic views across the valley, then the train became enclosed by hills again, and the view was lost until we turned the corner.

I write in my notebook comments such as 'golden ridges', 'beautiful winding shapes', 'soft fields dimpled', but I don't remember many specific scenes, just an overall sense of colour and form, and the sun coming out as the storm ended, lighting the valley in a purple and golden glow.

While there is something so passive about watching a landscape from a train window, it is a way of seeing places that I often find most beguiling. Perhaps it is because the movement of the train gives you a tantalising glimpse and then snatches it away, leaving an abstract impression to enhance and romanticise in memory. I imagine how strange it must have been for people seeing the landscape whizz past for the very first time, when railways were first introduced to Britain in the 1830s; to see it as a whole and then unravelling in such a short space of time.

Finally the train starts moving again, and the hills become more polite as we near Skipton.

BIRMINGHAM TO THE M5

A Forgotten Thoroughfare

When you step down onto the canal path off New Canal Street, it's as if you are stepping sideways into an alternate version of Birmingham made up of a complex network of waterways, locks and bridges. It *is* part of the city, and indeed was intrinsic to its development, yet it is an entirely different place to the world above ground.

Around me, purposeful, red-brick industrial shapes – factory chimneys and triangular roofs – emerge out of a thick foliage of cow parsley and elderflower that feels too big for the space, as if it is smothering the canal. I recall walking along the River Cam, where the banks were lined with similar hazy overgrown foliage, but

behind it lay miles of flat fields. Here, I am hemmed in by miles of urban landscape, fully peopled. But this does not have a stifling effect, rather a sense of walking through an air pocket in the dense mass.

I walk through a long tunnel, anxiously focusing on the light emerging at the other end. Time slows down and I am in here for hours. It's a summer's day, but right now I feel as vulnerable as if I am walking through an alleyway at night. The Union Canal Network was built for the transport of goods, before the railways, but it was also utilised by networks of thieves, gangsters and smugglers for less legitimate ends. These tunnels are pockets of darkness both physically and metaphorically, little areas of inner-city night-time in the middle of the day.

I emerge to an area where the pavement is arranged in a circle ringed with benches in a strangely hopeful idea of leisurely contemplation. Every surface is covered in graffiti and seems an unlikely place for a peaceful sit or social gathering.

While I am usually unmoved by street art, a tag or poster of a purple triangle adorned with an 'all-seeing eye' stares out at me from the wall. This feels appropriate, as there is a sense of walking through a very different civilisation to that of the world above. I imagine I am in a sinister dystopian dimension where eyes watch me from walls. Below me on the path, weeds grow up between the bricks. They are agreeable and exotically shaped, and I imagine I am quadrupled in size looking down at trees. This doesn't seem so utterly

unfeasible here. A canal path information board is covered in graffiti, like the rusted one I saw in Erith. The graffiti is perfectly placed, far more telling an informant than the neat rows of summarised historical facts it covers.

The scene becomes more surreal still as I find myself walking through Birmingham Science Park, where shiny, futuristic buildings, all panes of glass, emerge from behind the bank. The surroundings that happen to fringe the canal alter its atmosphere, but never overpower its own distinctive logic and sense of place. Like an aboriginal song line, it does not exist in terms of its geographical location, but as the path it carves.

I pass a bridge with its structure reminiscent of a molecular model, and soon the canal opens out towards Deep Cutting Junction. There is a combination of renovated Victorian factories and warehouses converted to chain pubs and aspirational flats. The Barclaycard Arena dominates the scene, and I pop into one of its many chain restaurants to use the toilet. Moving on, I pass three barges painted in a traditional fashion, with Roses and Castles decorations on their paintwork and on jugs and pots balanced on their roofs. While I've always had a love for the traditional folk art of canal culture, this is too shiny and pretty. It's as if the rich, gypsy culture of the canal people is being momentarily Disneyfied.

This comes to an end pretty quickly as I turn the corner and begin the long stretch towards St Vincent Street Bridge. The tasteful luxury is replaced by working factories and dilapidated industrial buildings. The weed jungle springs back into life, and the discerning folk art of barges traded again for elaborate graffiti tags. They are at quite intense levels here, covering walls and bridges, making the buildings that back onto the canal lose their definition, becoming almost camouflaged in the tangle of 3D letters and scribbles. The blue face of a woman with a black mask and a yellow hood, grinning demonically, the tiny dots of her pupils surrounded by thin black circles, catches my eye and, again, I have

an unnerving feeling of being watched. I look down in the water and the street art is reflected, softened and blurred.

I am exiting the civilised world; the graffiti becomes smothered by thick shrubs and trees as I move away from the centre of the city. Ahead of me I see a lock with a structure on it that looks like a red-brick column, but as I near it turns out to be a wall about ten metres long, the height varying and weeds bursting out of its top, and it gradually diminishes in height. It has a stateliness, like a cruise liner. Its shape and structure underlines the feeling that this canal walk is giving me, of the world losing a dimension. I am in a flattened and stretched place. I imagine this scene as a Victorian cardboard theatre, where different parts of the set are posted through slots.

I continue along this ragged, overgrown stretch, past the odd person fishing and a loitering man clutching Special Brew. Even though I am walking through one of the UK's most densely populated cities, it feels desolate, and oddly the leafier the canal becomes, the seedier it feels. In the height of the canal's operation, the people who lived and worked on barges were seen as rough, and, in spite of those families dispersing into mainstream landlocked society a century ago, it still feels disreputable here.

Moving on to the Old Main Line when the canal splits at Smethwick Junction, it becomes more manicured and scenic. Yet as I pass the beautifully restored pumping station I see a man sitting on a bench and I feel uncomfortable and vulnerable. The path narrows and gets rougher, and the trees and foliage on either side grow denser. There is the deafening roar of the M5 motorway ahead.

When you reach the motorway, it's as if you are stumbling across a ruined temple in a jungle. Its supporting columns tower around you, smothered by overgrown vegetation. It makes a roof overhead, sunlight seeping through at the sides. I follow the path along the water's edge through this desolate place, feeling utterly alone.

FRINGFORD AND JUNIPER HILL

A Universe inside a Hamlet

The faded yellow corn is swishing audibly in the vast cornfield, on the south-east side of the village, as our dogs race up and down. Fringford, North Oxfordshire, is what Candleford Green was based upon in Flora Thompson's semi-autobiography *Lark Rise to Candleford*, where 16-year-old Laura comes to assist the village post mistress. In her books, Thompson paints a lavishly detailed world of late-Victorian rural life that, like the best literature, transports the reader to a specific point in time so vividly that you feel that you've lived in Laura Timmins's cosy world.

The countryside is flat and wide. It has a certain elegance, but is not overly striking in its beauty. I think of the walks that Flora did on her post round – her almost psychedelically vivid descriptions of the natural landscape – and while our surroundings are very pleasant I find it hard to reconcile the two. This tiny corner of England was young Flora's entire universe, whereas we have just swooped in for a couple of hours. Standing in the cornfield I envy the minuteness of her universe. I am struck by a sensation of how, with the twenty-first century's ease of high-speed travel, our horizons have expanded infinitely, but that the richness and sensations of our immediate surroundings have shrunk and diluted.

Katie and I walk down Fringford's main road, passing The Old Forge, which is the former post office where Flora lived. The village is pretty and unspoilt, with low-roofed thatched cottages. It is understated and dignified, less chocolate-boxy than the nearby Cotswolds. But what is striking about walking here is its emptiness. The only living beings we have encountered so far are the barmaid in The Butchers Arms and a few goats. Flora Thompson described a vibrant place, swarming with notable characters, and several thriving shops and businesses. Fringford today feels like an abandoned stage set, its inhabitants shopping and working a car ride away. In her books, Flora was always keen not to romanticise the past. She stressed how overall the lot of the common man had significantly improved by 1939, while acknowledging the loss of something special with the extinction of village life. It is a sentiment that fits this pilgrimage perfectly.

A few miles north, we arrive in the hamlet of Juniper Hill/Lark Rise. While she writes that it is very small, in Flora's childhood it was the only world that she knew. Inhabited by only a handful of people, in the book it stretches infinitely into a universe abounding with tragedies, stories, struggles and the vibrant minutiae of daily life. But, as in Fringford, there is no one

here, and we potter around the entire place in a couple of minutes. The sky is overcast and I imagine the sounds of the children's games 'Here Come Three Tinkers' and 'Isabella', the gossip of the women and the singing of the men in the pub enriching and enlivening the place, whereas all we can hear is the hum of a tractor and the roar of distant traffic. We finally find Flora's house, plain and whitewashed.

In the nearby Cottisford, I pop into the parish church quickly before we drive away from this corner of the world. I see the list of births and deaths of the Timms family (Flora's maiden name) in handwritten script on the church wall, and the world momentarily expands again to the size and depth it had in the past.

CARDIFF

Decorative Details

When I think back to my day in Cardiff, it's not the grand buildings of the city centre or the sweeping views of Cardiff Bay that appear in my mind's eye. It is small, interesting details which led me on a detour that enabled me to make a more-than-superficial connection with the city.

Crossing the River Taff to the Fitzhamon Embankment, you are met by a row of four pale-coloured large metal abstract forms that look like giant, three-dimensional food-inspired textile prints. They are a piece of public art created by Andrew Rowe, David Mackie and Heather Parnell in 2007 – inspired by residents and school children from Riverside, the four sculptures represent seeds and spices used in local recipes. These small but beautiful details of everyday life inherent in the diversity of the community are made large and permanent: part of the physical fabric of the city.

Looking west, away from the river, you see rows of late-Victorian two-storey terraced houses. They are similar to terraces elsewhere, yet different to home: window frames are

painted cream instead of white and wooden panelling is hunter green. After the numbing effect of ubiquitous chain shops and businesses of the city centre, sauntering through a quiet, residential area is most appealing.

I start to notice intricate decorative ceramic tiles on the inside walls of each house's porch: art nouveau lilies, roses and flourishes, no two the same. Partially obscured, in slivers at odd angles, narrow triangles of pattern and colour behind muted brick, these designs stem from a period of art and design which took great influence from the Orient.

Grangetown is an area of Cardiff that developed post-1850 as a place for workers to live. Since the mid to late twentieth century, many South Asian and Somali immigrants settled here. It is apparently becoming gentrified, and as I wander around its peaceful, leafy streets, passing Indian supermarkets and terraced houses, the spires of the Grangetown Sikh Gurdwara glisten over the rooftops. The cultural mix enriches my surroundings.

As I walk I overhear a conversation between a boy of South Asian heritage and his dad. The boy is complaining that his school friends are mean to him because he supports Bristol in the football, which he does because that is where he lived until he was five. 'I am English and Welsh,' he says.

At Paget Street I stop at St Paul's Church. My eye is caught by the decorative iron railings, rusted and peeling, revealing rich layers of blue and red, white, yellow and orange. It is an accidentally attractive texture. To me, it is the layers of diversity, culture, history and experiences embodied in small details which make a place beautiful.

CERNE ABBAS AND IMBER

Village Mysteries

From the viewpoint at the Cerne Abbas car park, the infamous chalk figure is difficult to make out; the chalk is so faded we can only see a subtle impression of the iconic image. It's an odd thing, to make a trip to see something that you have seen in photographs, paintings and wood engravings so often, and to find that the real thing is a faded and indiscernible shadow of its representations.

In the picturesque village of Cerne Abbas we proceed to potter around, the image of the giant is everywhere. The eccentric village shop sells all manner of giant souvenirs, including aprons (where there is the option to cover his modesty), shortbread, tea towels, mugs and sets to knit your own. I buy a selection of Cerne Giant ales for my brother.The giant is all, and yet the image I saw from the car park was indistinct.

The original purpose of the Cerne Giant is unknown. It has been thought that it was created in Roman times to represent the Roman god Hercules, or possibly that it is of Celtic origin. Recent scholars suggest that it was created as a prank in the seventeenth century, as no records of it exist before then. As with the Shell Grotto at Margate, cryptic additions to the natural landscape inspire devotion.

The village has other enticements. Through the churchyard of the old abbey, which was a thriving monastery until the Reformation, there is an old well. A framed information sheet with handwritten calligraphy describes the legend of the Silver Well, where St Augustine struck the ground to draw water for thirsty, temperate shepherds. Apparently, this tale was invented by Benedictine monks to attract pilgrims. It pleases me that even medieval monks were concocting secrets and tales to attract visitors.

We drive out of the nestled hills of the Dorset Downs. Then, once inside the British Army training ground, we pass through gates covered in alarming signs saying, 'Keep Out!' and 'Danger Explosives'. Rusted tanks dot the landscape like dead dinosaurs. The contrast between this appealing English geography and the paraphernalia of the military is disconcerting. Being somewhere like Cerne Abbas, it's as though the village and landscape exist to support a concept of the English ideal: pretty, pastoral, with romantic secrets running through it, but here with the tanks and assertive signs the idyll is turned on its head.

As you walk into Imber, you pass piles of breeze blocks and have to walk around

a sign that says, 'DANGER. NO PUBLIC ACCESS'. Imber's civilian inhabitants were evicted in 1943 to provide an exercise area for American troops during the Second World War. It has remained under the control of the Ministry of Defence and public access is limited to a few days of the year. What strikes you first off are the rows of council houses. Too big to be from the 1950s, they are empty, pale bare brick, with no glass in the windows. It's like looking into a row of skulls.

The church is still in operation and hosts occasional services. We peer at it through the diamond-patterned wire fence, and it feels odd to be shut out of a country church in such an inner-city fashion. Just an hour before and a few miles away, we were standing chatting to the elegantly bohemian owner of the Cerne Abbey rectory, petting her spaniels in the sunshine.

Within a small distance are these two different villages, one of which actively discourages visitors and one that entices and caters for them, but both equally rich in very different kinds of mystery.

HARLOW

New Town World

The Market Square in central Harlow is quintessentially post-war low buildings lined with pastel-coloured tiles with grid-like windows. To my right is the clock tower: a low-rise concrete building adorned with tiles of bright-blue-and-white oblongs, with a black metal clock face on top of it. This facade is like a mid-century textile pattern made as a building: bright, optimistic and deeply dated. The top half of a building, leading down Boardwalk,

features a patchwork arrangement of different marble textures cut out in irregularly shaped hexagons. These patterns are deeply satisfying. Yet the pleasure I gain from my surroundings is not entirely comfortable. I admire it aesthetically but I wonder what it would be like to actually live here. In the middle of the square is a sculpture called 'Meat Porters' by Ralph Brown (1959): a visceral bronze semi-abstract of two men holding a large pig carcass. This rather violent sculpture, the dated facades

and the old-fashioned name 'Market Square' come together to form an odd space, rife with contradictions.

Harlow New Town was built in the aftermath of the Second World War. Like many other New Towns, it was designed to ease overcrowding in London created in the wake of the Blitz. Frederick Gibberd was the architect behind Harlow (as well as of the Liverpool Metropolitan Cathedral), and it was largely constructed in the 1950s. The weekend previous to my visit, a Polish man was beaten nearly to death in one of the many xenophobic attacks occurring across our land in the wake of the EU referendum. This town, created in a spirit of tolerance and optimism after the horrors of the war, now appears to be home to an aggressive strand of nationalism. There is a sense in these post-war New Towns of lofty, ideological architects and town planners performing social experiments on working-class people, which creates an element of discomfort to the Harlow Experience.

Coming out of the rather down-at-heel Harvey Shopping Centre, I come across St Paul's Church. Designed by Derrick Humphrys and Hurst, the church was completed in 1959. Its brown bricks and thin, glass panels form a modernist pattern, with a tall pointed green spire sprouting from its

top. It is Sunday, and hymns emanate from the large hall. The agreeable pattern of the church and the joyful sound of the singing momentarily bring these buildings to life.

I am following the Harlow Sculpture Trail. The Harlow Art Trust, established in the 1950s, acquired works by up-and-coming sculptors and provided a permanent exhibition of their works. I go in search of Henry and Joyce Collins's mural, 'Harlow', which from the tiny picture

on my map looks to be temptingly 1950s and is said to be on the ground floor of BHS. However, on arrival at its location, I realise that it is literally in BHS, which is now closed; a photocopied piece of paper inside the glass-fronted window, revealing an empty shop floor, says the store is now closed and customers' orders can be collected from BHS St Albans.

In the Civic Centre lobby, behind glass, sits 'Family' by Henry Moore. The building is closed, and I admire the sculpture through reflections and shine; there seems something symbolic about this family just sitting there in this empty government building while others brave the elements outside.

A tall, totemic bronze sculpture resembling an abstract, irregular spine presides over the Water Gardens – which is flanked by the obligatory chain restaurants that feature in any town shopping centre across the land. The original town centre was unpopular, deemed far too mid-century and ugly, and was replaced by generic early 2000s' glass and steel. It already looks sad and cheap, while many of the town's original buildings have a listed status now.

Thank heavens the Water Gardens itself has been left intact. It is a long rectangular pool in front of the Civic Centre with tiered gardens, benches and water fountains. The walls of each level feature reliefs by William Mitchell, whose work I admired in Liverpool, some of which are fountains while others are just decorative panels. They are rich and complex abstract patterns rendered in concrete, some of which combine stones and irregular-shaped tiles. Zig-zagged grooves contort into formations suggesting weird combinations of abstract maps, tribal masks and monsters. As in Liverpool, I feel as if spirits of monsters or mythical places are trapped in these walls, frozen in time, or that they are mysterious maps to unknown locations. A large new Asda overlooks the gardens, and on its wall is another relief by William Mitchell, 'Heraldic Panel'; narrow in height

and long in width, it features elegant, wing-like shapes in concrete, with suggestions of shields and birds. Again, I am struck by the extreme contradictions of this place, with these wonderfully idiosyncratic reliefs, this Henry Moore, alongside the utter generic mundanity of supermarkets, chain stores and restaurants.

A couple of miles north-east of the centre of Harlow, in Mark Hall, I walk through leafy, curving streets of 1950s' council houses. It is the epitome of post-war Britain, unglamorous, quiet and functional. The Glebelands estate is a large low-rise block of pale yellow brick, surrounded by dried grass that almost matches the surface colour of the buildings. On a cobblestoned area in front of it stands 'Contrapuntal Forms' by Barbara Hepworth (1951). It is rendered in blue limestone from County Galway, Eire, and the two figures, like sanded-down robots,

stand at about nine feet on a plinth, with narrow holes in their chests. This sculpture was commissioned for the Festival of Britain. I circle around the figures in the intense afternoon light, basking in their power. The gentle slopes of their forms are so anonymous and mysterious yet full of a profound emotion. I marvel at how this wonderful piece of art is nestled in this no-where place. I recall looking at Hepworth sculptures in the Pier Arts Centre in Stromness, Orkney, a purpose-built centre in a poetically bleak and beautiful place, and how well her forms seemed to fit in that context. Yet here they also seem perfectly at home. Perhaps it is the universal quality of the art or the consistency of mid-century aesthetic, or just the novelty of seeing it in a suburban council estate. I am the only person here.

At the entrance to the Gibberd Garden house and grounds, there is a jolly, village

fete atmosphere; families and couples weave around the retired volunteers and ice cream stands. Frederick Gibberd, architect of Harlow, made this place his country retreat and eventually his home, years after he began work on Harlow. Buffered from the estates of Harlow by the tasteful Harlow Old Town, Gibberd modernised the Victorian farmhouse as much as planning permission allowed and built an eclectic sculpture garden throughout the grounds. Mythical beasts, sculptural forms by the likes of Gerda Rubinstein and Elisabeth Frink, nestle alongside classical columns among the trees, little hills and hidden chambers of the garden. It's like a delightful treasure hunt. And at the bottom of a dramatic poplar grove, an amateur dramatics group performs *A Midsummer Night's Dream*; Shakespeare's famous lines float through the leaves and around the abstract stone forms.

In spite of its obvious charms, after the jarring oddness of Harlow there is a smug preciousness about this place. Its multifariousness is perfectly curated. In the living room of the house, where Danish furniture is playfully teamed with a wall of Staffordshire dogs, I wonder if, given the choice, those living in the New Town might have also enjoyed some old among the new.

I look down at a stone model of a town, scattered with leaves, and it occurs to me that Gibberd had a role of puppetmaster. From his private land near his great project, generations of people's lives were shaped by his grand vision. But this has been the case in England in one form or another for thousands of years. This notion of Gibberd as lord of the manor, looking down over his model towns, is perfectly encapsulated by the small-scale model of Liverpool Metropolitan Cathedral leaning against his fireplace.

SAFFRON WALDEN

In Praise of Pargeting

I first noticed pargeting on the Thoroughfare of Halesworth in Suffolk. Its subtlety means that you can easily miss it if you are not looking carefully: the shadow of herringbone grooves on the white paint of an old cottage. Since then, I look out for it whenever I am in Suffolk or Essex.

Pargeting is relief decoration on the walls of cottages that is particular to this part of the world. It is usually white on white, or whatever colour the house is painted, and there are standard patterns: wavy lines, herringbone or half-lined circles reminiscent of traditional Japanese wave patterns. On grander buildings you find more elaborate and individual decorative mouldings but, even on its most lavish examples, because the pattern is created by the shadow of the raised moulding, with no extra colour, there is a subtlety to it that appeals to me.

One of the finest examples of pargeting is on the Old Sun Inn, on Castle Street in the medieval market town of Saffron Walden, which is where I am today. The whitewashed exterior features bunches of pears hanging off twirly flourishes, and stylised birds and strange, disembodied creatures form symmetrical patterns. On the front face of the building are two rather naive-looking figures, one bearing a sword, another a club. And if you look

carefully, tucked away on the wall leading back to the main body of the house, you see a little dog in a raised circle and a disembodied leg next to a window. In a corner is the faint motif of a sun and a coiled swirl repeated above it. I enjoy this rather mysterious symbolism and the combination of random solo objects with more symmetrical, decorative motifs.

Early examples of pargeting date back to Roman times. It was at the height of fashion in the sixteenth and seventeenth centuries, and there was a great deal of it in London before the Great Fire in 1666. It fell from favour with the onset of industrialisation – people wanted new machine-brick facades – and has seen no real big revival aside from a flurry of interest in the Arts and Crafts period. But pargeting never really went away in East Anglia, maybe because of the absence of major industrialisation in the area. I like that this pre-industrial tradition remains here, and is so distinctly local. As with the drystone walls of the Lake District or the red-brick buildings of Manchester, the emotional reaction we have to specific materials, colours and decorative arts and crafts goes deeper than just aesthetics. In these patterns lie histories, ideologies and more profound truths about people than can be put into words.

STIFFKEY AND BLAKENEY POINT

Saltmarshes and Seals

To reach the saltmarshes from Stiffkey, you cross a large, elegant field that sweeps down to a high row of trees that conceals the strange saltmarsh world that lies beyond. Go through a gap in the trees and you find a moonscape of tufted scrubby grasses, sea lavender and sea heath sprouting from the mud in a mixture of muted green and brown. They form a camouflage pattern over the marsh surface, folding inwards, where the detailed network of creeks curve through it.

We are aiming for the small wooden bridges in the distance. They seem to be sitting arbitrarily on the flats, not bridging anything in particular, but in fact they connect areas of marsh during high tide. The complexity of this landscape and the lack of height from which to observe it make it hard to make out this transition.

The surface of this place is riddled with crevices. The rivulets make a linear route to the bridges impossible; we twist around and come to barriers at every turn, wondering that such a flat landscape should put up so many obstacles. Ada majestically leaps over the water and patiently waits for us to take a roundabout route to meet her. The craters glisten in the sunlight.

The bridges are small and beyond them the wet mudflats stretch out and seem to rise before the horizon. The sea isn't visible, but it has styled ridges and brought tiny shells underfoot. Beneath our feet is a swirling patchwork of textures that echoes the flinty walls of the cottages in Stiffkey. It is so different from walking up the ridge of a fell or a mountain, where your surroundings crystallise into a view behind you. Here, the land is swirling around us, there is no near and no far, just ever-changing patterns.

The North Norfolk saltmarshes, and Blakeney Point across the water, have been protected as a Site of Special Scientific Interest since 1954. It has a delicate balance between land and sea, which provides habitat to unusual and particular flora and fauna, such as spiral tasselweed and sea lavender. And indeed, it is a place where all the supposed rules of reality seem to morph and become nebulous. It is both land and sea, altering dramatically according to the time of day, looking entirely different from every angle. It is neither one thing, nor another. In September 2016, politically it feels as though

dividing lines are being drawn up everywhere and the complex, overlapping contradictions of life are being ironed out, and there is something deeply profound about being somewhere where the geographical boundaries between states are so unsubstantial and capricious.

When the tide starts to come in, six of us make our way west, along the coast path towards Well-next-the-Sea. Now, the slight elevation and distance enables me to make more visual sense of the saltmarshes. From this viewpoint, creeks cut through the grasses and shimmer like rivulets of molten silver. Above, streaky clouds create lightly sketched versions of these patterns. The path leads inland at times and, behind a curtain of trees, beautifully curved ploughed fields, with their neatly rolled hay bales, are a picture of a familiar and demarcated England.

As we near Wells, the areas between marsh and sea become more distinct, providing moorings for boats and signs of civilised life. The landscape is now grounded with a tangible, everyday reality.

Out on a boat at Blakeney Point, the tide is high and the land fragmented. Blakeney Point is a four-mile spit, which on a map appears to curve protectively around the village of Blakeney and the saltmarshes. There is a ruined medieval monastery beneath the sea which is due to be buried under sandbanks and lost to the world in coming years. The spit is known for frequent sightings of rare interloper migrating birds, like the wheatear and the icterine warbler, blown off course by storms. Being out on the boat, my bearings have gone. We pass sandbanks peppered with perched sailing vessels that curve away from us then appear again from opposing directions. I admire the unusual blue structure of the Blakeney Point Lifeboat House; a strange houseboat – a wooden hut perched on top of a blue boat bottom – is moored in front of it. This vessel seems fitting, encapsulating the spirit of both land and sea.

We begin to see seals, grey and common. Our first sighting is of one frolicking in the shallows near us. Its slippery grey head emerges splashing from the water. Soon we are metres away from a herd of them, basking and rolling in joyful decadence on the sandbanks. These creatures, with the characterful and familiar faces of domestic dogs and their bulbous fish-like bodies, living between the water and the sandbanks, like the houseboat, are the perfect inhabitants for this in-between place.

Our guide tells us that very specific tides are enabling us to get so close to the seals. The experience of being here is dependent on so many geographical and environmental factors coming together for brief periods and then shifting and morphing into something new, like a speeded-up version of the world's ever-evolving geology.

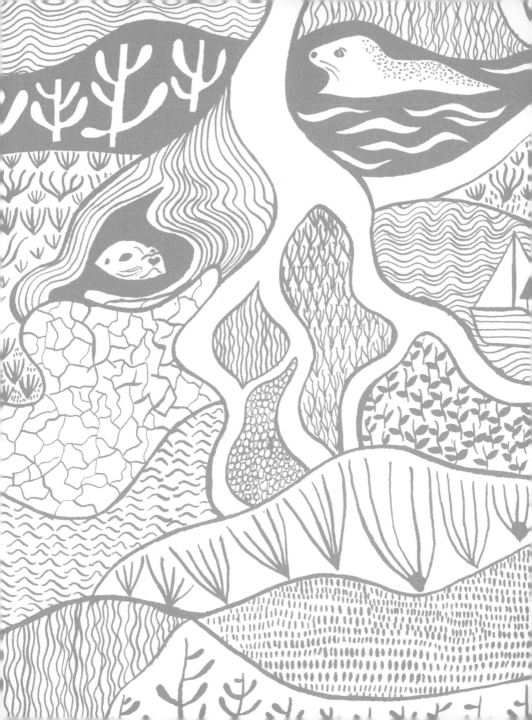

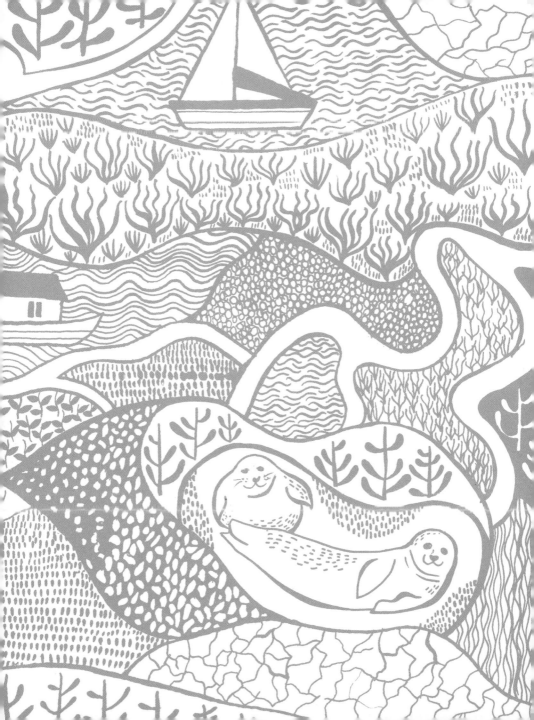

KINGSTON-UPON-HULL

Saturday Night in the City

On foot on a Saturday afternoon, central Hull is an assault course of roadworks. Looking up you admire the intricate stonework on the grand Victorian buildings, but if you shift your gaze downwards you find the pavement is liberally peppered with piles of vomit. Kingston-upon-Hull is a city of contrasts: once wealthy and built on seafaring and whaling, and the adopted home of one of the nation's favourite poets, now fallen on hard times. It seems everywhere you look these contrasts present themselves.

The historic town centre features numerous Victorian shopping arcades but they house rather seedy or unexpected shops, including one entirely devoted to teddy bears, with a cross proprietress.

Ye Olde Black Boy is one of the oldest pubs in Hull. Dark and candlelit, serving real ale and traditional pork pies, it is a place where wealthy shipping merchants once sat and cut business deals. The walls are covered with deeply politically incorrect depictions of Afro-Caribbean men and slave trade paraphernalia which, while I'm sure it's meant in a knowing and ironic way, is odd and uncomfortable. In fact, Hull did not have a slave industry, which was more the reserve of Britain's west-coast cities, and William Wilberforce, who was a key figure in the abolition of slavery, was Member of Parliament for Kingston-upon-Hull.

A short taxi ride away and we are in the brightly lit art gallery of the Brynmor Jones Library at the University of Hull. Gazing at the black-and-white swirls of a Gertrude Hermes print, we admire a Vanessa Bell lithograph and some Duncan Grant studies before wandering back out to the campus, which

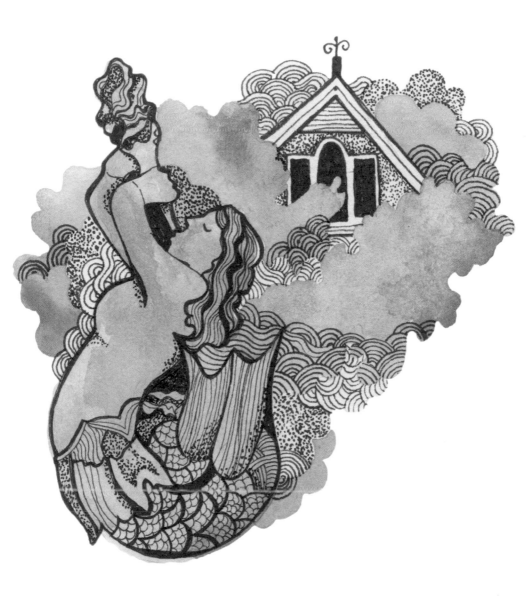

is tasteful and quiet. Ivy clads the red-brick walls.

In Pearson Park, the daylight disappearing, loitering 12-year-olds, the fading Victorian grandeur of the conservatory and the cupola rescued from Cuthbert Brodrick's town hall all combine to create a poignant atmosphere that feels uniquely British. At the bottom of the park, we identify Philip Larkin's building, where he inhabited the top floor with views over the park for much of his life. The garden is overgrown to the point where you can only see the pointed roof, and a rather aggressive 'Beware of the Dog' sign adorns the gate.

In the heart of The Avenues, on our way to our home for the night, is an opulent fountain, where mermaids blow conch shells in a circular formation. Around us are vast late-Victorian and Edwardian villas, featuring striking diamond patterns and arches. These streets are a remnant of Hull's glory years and their opulence is combined with a certain sleepiness.

In the living room of our hosts, Mark and Andy, we hear descriptions of the area's annual Open Garden Weekend. Residents wander in and out of each other's back gardens, some of which are huge and feature apple orchards. James and I make a pact that we will return to Hull for it. Sitting enjoying a wonderful supper, we observe how it's only 8 p.m. but we've already inhabited a lifetime of contradictory realities.

SPURN HEAD SPIT

Extreme Geography

Nearing Spurn Head Spit, you start to see signs in cottage windows saying '#keep-spurnwild'. Hearing about this campaign on the radio was what first alerted me to the existence of this place. Local residents are campaigning against The Wildlife Trust's plans to build a large visitors centre with a car park at the start of the spit. The general argument against it seems to be that the planned building will be vast and ugly, encouraging huge amounts of visitors that the village of Kilnsea would not be able to accommodate. Essentially it would disrupt and alter the delicate balance of life that exists in this narrow, endangered landscape.

The nearby coastal villages and the spit itself are also under serious environmental threat. Spurn is a series of sand and shingle banks held together by sea

buckthorn and marram grass. It is 50 metres wide and stretches out three-and-a-half miles across the Humber estuary. Its extreme geography leaves it open to the North Sea's ravages and, according to our taxi driver and the residents we speak to, the coastline of south-east Yorkshire is being reclaimed by the sea at an alarming rate. There is a strong sense of this place being under siege by both commerce and the forces of nature.

When you begin the walk along Spurn, you can see the spit curving out ahead of you. On one side is the River Humber and the other the North Sea, but after a certain point the central ridge rises, and you must either choose a side or walk along the middle, where the views are partially obscured by raised banks of marram grass. We've decided to focus inwards for our outward journey, gazing across the richly patterned mudflats and, split into semi-relief by their system of creeks, over to the faint grey outlines of Grimsby and Humberston. But glancing over your shoulder at the still-visible North Sea coast, the vista is dramatically different: a station of wind farms perches on the rough blue waves breaking over pale sands.

Picking our way along, my eyes flit between the view and the abundantly detailed world beneath my feet: multicoloured pebbles and seaweed on complex, veiny rivulets. The spit has been destroyed and put back by floods and storms many times: like reused clay or dough, broken down and reformed, absorbing fragments of everyday life into its fabric.

Eventually we climb up onto the path with more distant views: of the Humber, the swirling patterns of the mudflats, large industrial boats, the curve of the spit and the lighthouse in the distance. The lighthouse is tall and definite, restored: a visual anchor point. But the settlement we reach at the end of the spit is an odd collection of suburban-looking terraced homes for RNLI workers, disused Second World War bunkers and rather abandoned industrial sheds.

The difference in character on the return journey is startling. It's as if you have been picked up and transplanted elsewhere: a place of white sand with rhythmical grooves on the ground. We pass a lone piece of driftwood sculpted into bone-like form. Battered and decaying wooden groynes stand in rows across the sand, casting long shadows like a wild imitation of the wind farms out at sea. Orange and turquoise rope wraps around them, creating tastefully coloured schemes.

Out at the tide we see a lone seal pup lying in the water and we talk to the two marine rescuers. They tell us he is fine, has probably recently parted company from his mother and is just having a bask. After the vast colony of seals we saw in Norfolk, this lone seal feels distinctly vulnerable, but it fits with the uniqueness of the environment. I look down and see more rivulets decorated with pebbles, the same as on the other shore of the spit, and they unite the two in my mind's eye.

The spit flattens and the two paths begin to merge. The tide starts to come in quickly, and the fragility of this place is heightened with the narrowing of the land.

SUNDERLAND

Histories in Pottery and Glass

Love
There's sunshine on the sea my love
There's beauty oe'r the skies,
But fairer seem thy looks my love
And brighter are thine eyes.

The glass cases in the pottery room at the Sunderland Museum contain a world of stories. In the eighteenth and nineteenth centuries, pottery was a huge industry in Sunderland, with 300,000 pieces being exported annually in its heyday. The distinctive shiny pink of Sunderland lustreware was much sought after and later even imitated by Staffordshire potteries.

A large proportion of the bowls, jugs and plates on display have a maritime theme. Many depict detailed line drawings of famous ships and the iconic Wearmouth Bridge, framed by the distinctive pink or boldly patterned zig-zagged brushstrokes that contrast pleasingly with the intricate etched images they surround. Sunderland's most notable industry was shipbuilding – vessels were built here for over 600 years, its last shipyard closing in 1989, and it was known as 'The Biggest Shipbuilding Town in the World'. The decline of its industries and excessive Blitz damage meant that the latter part of the twentieth century was not kind to Sunderland: the city has suffered from high levels of poverty and unemployment. And these images, printed onto earthenware, are a window into a proud maritime past which is difficult to reconcile to the late twentieth-century

architecture and small fishing trawlers that characterise the River Wear now.

Many of the pots have a decidedly sentimental tone: illustrations of sailors being seen off by Victorian women mournfully waving handkerchiefs, entitled 'A Sailors Farewell'; rhymes such as, 'Far from home, across the sea, To Foreign Climes I go, While far away, O think on me, and I'll remember you.' These items would have been given to spouses, sweethearts and family members left behind, and they perfectly embody the Victorian romanticisation of sailors. Despite the saccharine sentimentality, they are moving.

While many of the ceramics commemorate historical events, there is a whole case of items honouring marriages, births and deaths. A simple jug inscription is framed with a thick black line, similar to that which featured on Victorian envelopes containing news of a death. Names of newly-wed couples are ringed with flowers and a particularly striking piece is a marble-glazed baby's crib. There are also religious pots, featuring cautionary illustrations of the dangers of the 'demon drink', and I marvel at how such a comprehensive spectrum of Victorian life is present in these earthenware objects.

After crossing the Wearmouth Bridge and a short walk along the Wear, I am looking at more plates and cups in museum cases at the National Glass Centre. Nobleman Benedict Biscop brought the first glaziers over to Sunderland from Gaul in AD 674. Fourteen centuries later and the glass factories were thriving, but foreign competition led to their gradual decline in the twentieth century.

There are similarities in themes and decoration to the pottery; famous ships and the Wearmouth Bridge are reoccurring motifs on engraved plates and goblets. The glassware is particularly affecting because it moves and alters according to the light, and always features whatever is behind me. While solid, its appearance is inseparable from its surroundings, making it more intangible and mysterious than the ceramic pots.

I am particularly struck by the distinctive patterning of the Henry Greener and Co. pressed glass; the elaborate graphic design and typography seem decades

ahead of their time. The memory glass – simple glass cups, inscribed with handwritten descriptions of accidents and deaths – is particularly poignant. This was made by glass workers often to raise money for the families affected by accidents, and the

delicacy of their materials and the hand-writing on a brittle, transparent surface enhance the emotional impact of the object.

In the next case along are two examples of friggers – two solid, black glass rolling pins on which are etched inscriptions of the Wearmouth Bridge and a ship and a date. These items were an opportunity for workers to develop their creativity and were usually given as love tokens. The splintered, ghostly quality of the marks is both delicate and crude, and like the memory glass the physical quality of the objects gives them a vulnerability that is deeply touching.

Later, as I stare out at darkness from the train window, I reflect that each object in the museums is a porthole, connecting the observer to Sunderland's history, from the deeply personal to the historical and spiritual. The power and importance of everyday decorative arts and crafts as a means of understanding our world should never be underestimated.

PLYMOUTH

An Abstract City

To get to the Cremyll Ferry stop, you walk past slim, run-down Georgian houses, cafes and strange pubs, and the elegant grey pale limestone walls of naval buildings. Plymouth is a proud naval city, a gateway to Cornwall, but it has a definite roughness to it. The city centre was virtually flattened during the Blitz and was entirely rebuilt after the war in the typically brutalist style of the vision of Sir Patrick Abercrombie. It provokes strong reactions still today. Plymouth nestles between the River Tamar and the River Plym, surrounded by stunning coast and countryside, and visitors to the area often dismiss it as a blot on an otherwise picturesque landscape of rolling hills, coves and cosy villages. But I like it, it's a lively and friendly place, and its grittiness contrasts nicely to its picturesque surroundings. To me it is a perfect distillation of the contradictions of our land.

At the ferry dock, the view over the water to Mount Edgcumbe, on Cornwall's Rame Peninsula, has a kind of classical, heavenly quality, like the paintings of Gaspard Dughet, who inspired the layout of the park at Stourhead. The lodgepole pines sit agreeably on curved hills and Drake's Island sprouts out of the Plymouth Sound like a miniature of the mainland. Cornwall takes on a glow of being a mythical, promised land as you head towards it on the tiny ferry, and the city behind becomes the view. The crisp light is illuminating everything from within.

In ten minutes we've landed at the hamlet of Cremyll. Heading north around the headland, you get glimpses of Plymouth through the trees, and in the flattering autumn light the city becomes a white form, made up of planes of triangles and rectangles. It brings to mind illustrator Miroslav Sasek's

cityscapes from *This is San Francisco*, the view distorted into hundreds of pastel-coloured rectangles on white. Distance and dramatic vantage points transform a place into a completely different entity. The docks of Devonport and Morice Town become large shapes and appear futuristic in the dazzling sunlight. Three 1960s' tower blocks dwarf the low-rise landscape. Each has a different-coloured roof and stripe down the middle: Tavy in blue, Tamar in red and Lynher in green. The colours of 'thieves yarn', which the naval dockyards of Portsmouth, Devonport and Chatham used to identify their rope. This concrete, abstract mass is surrounded by the most perfectly rounded hills, and the contrast is beautiful.

As you walk up towards the ridge of the peninsula, the Church of St Mary & St Julian's spire pokes out of the top of the hill. When you let yourself into its little churchyard, most of the graves are old, thin and pale; there are hundreds in such a small space, a miniature city of human stories. The pale stone rectangles echo the shapes formed by the view of Plymouth. Lives forming abstract patterns from stone and concrete.

There is a huge curved field before I begin my descent into Cawsand. The emptiness with no view is almost as stunning as the view itself.

From a distance Cawsand is a collection of pastel-coloured cottage shapes, and up close it is a warren. Wandering around its narrow streets is like walking around inside a cubist painting: the narrow, zig-zagged paths form optical illusions of depth and space. Cawsand recently 'played' Victorian Margate in the film *Mr Turner*, and illusory angles lend themselves to this sort of disguise. Cawsand and its neighbouring Kingsand have a rich history of smuggling, as well as being fishing villages, which again seems to fit their maze-like quality. It is interesting to be in such a tiny space, to be enveloped by it, after looking at a whole city across a body of water.

After a pint of Cornish ale and a sausage and onion sandwich in The Rising Sun, I head to the beach. I clamber over

large, blackened rocks that merge into pink formations featuring swirling contours, echoing those I saw on rocks on Orkney six months ago. I like seeing this thread through the landscape to my earlier journey at the other end of the country.

Clear rock pool circles of reflected blue sky shine against the burnt black rocks. This area of coast is the Kingsand to Sandway Point Site of Special Scientific Interest, featuring volcanic rock that dates back to the Permian period, which ended 250 million years ago. Yet this peninsula is often known as the Forgotten Corner of Cornwall; it is missed by visitors heading further west, to better known destinations, perhaps because of its proximity to the grittiness of Plymouth and slightly out-of-the-way location.

As I walk along the South West Coast Path back towards my starting point, the shipping containers out across the sea glow a deep red in the dramatic light, as if lit up from inside. A bonfire burns at the little lighthouse near Fort Picklecombe and the smoke blows out across the sea over towards Bovisand Bay, the perfect combination of autumn and maritime. Weaving in and out of the woods of Mount Edgcumbe Park, passing follies, Tavy, Tamar and Lynher come into view again.

WHERE ALICE WENT

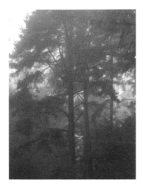

Stourhead
— Woodland to Parkland

From Gare Hill, Alice walked through Great Bradley Wood to Stourhead Park.
nationaltrust.org.uk/stourhead

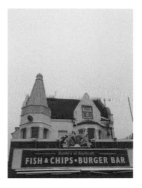

Southend-on-Sea
— Neon and Nothingness

Starting at Southend Victoria train station, Alice walked to Leigh-on-Sea via Southend Pier.
southend.gov.uk/info/200306/southend_pier_and_cliff_lift

Erith
— Esoteric Estuary

Alice walked the Erith to Old Bexley Village section of the London LOOP, starting at Erith station.
tfl.gov.uk/modes/walking/erith-riverside-to-old-bexley-village

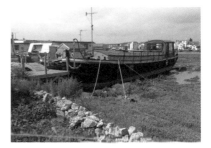

Shoreham-by-Sea
— Houseboats and Prayer Cushions

Beginning at Shoreham-by-Sea train station, Alice walked to the houseboats on Shoreham Harbour via the River Adur waterside path.
westsussex.info/shoreham.shtml

Lower Morden Lane
— Christmas Street

Alice started at Morden Tube station,
walking down Hillcross Avenue to reach
the southern end of Lower Morden Lane.

Liverpool
— Pilgrimage to a City of the Imagination

Staying at the Hope Street Hotel, Alice
walked to Liverpool Cathedral and Liverpool
Metropolitan Cathedral. The next day, Alice
took a Magical Mystery Bus Tour from the
Albert Dock.
hopestreet.co.uk
cavernclub.org/the-magical-mystery-tour

Port Sunlight
— The Factory Village

Alice went to Port Sunlight Village
from Liverpool, taking the train to
and from Port Sunlight train station.
portsunlightvillage.com

Bath to Bathampton
— Waterway Out of the City

Alice walked along the Kennet and Avon
canal path from Great Pulteney Street, Bath,
ending at Mill Lane, Bathampton.

Manchester
— The Land of Red Brick

Walking to the Whitworth art gallery from
Stockport train station, Alice then took a
147 bus into Manchester city centre.
whitworth.manchester.ac.uk

Dungeness
— Rust and Sea Kale

Alice began and ended her walk around
the Dungeness National Nature Reserve
at The Pilot Inn, Dungeness.
dungeness-nnr.co.uk

Portmeirion
— The Giant Folly

By foot from Porthmadog, Alice visited
Portmeirion Village.
portmeirion-village.com

The Ffestiniog Railway and Tanygrisiau
— Steam Train into Snowdonia

Taking the Ffestiniog Railway from
Porthmadog to Tanygrisiau, Alice walked
towards the Llyn Stwlan reservoir.
festrail.co.uk

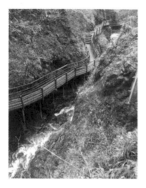

Glenariff Waterfalls
— Deep into a World of Moss and Water

The Glenariff Nature Reserve Waterfall Walk starts and ends at the Glenariff Visitor Centre.
walkni.com/walks/197/glenariff-nature-reserve-waterfalls-walk

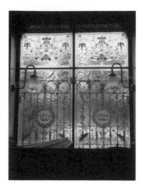

Belfast
— The Most Beautiful Pub in the World

Alice walked to The Crown Bar via The Bank of Ireland Building on Royal Avenue.
nationaltrust.org.uk/the-crown-bar

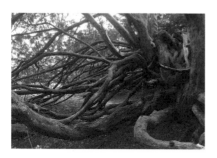

Castle Crom
— A Hidden Arboreal World

Alice walked around the grounds at Crom.
nationaltrust.org.uk/crom

Edinburgh
— Below the City's Surface

Starting at Dean Village and ending at Leith Harbour, Alice took the Water of Leith walkway.
waterofleith.org.uk

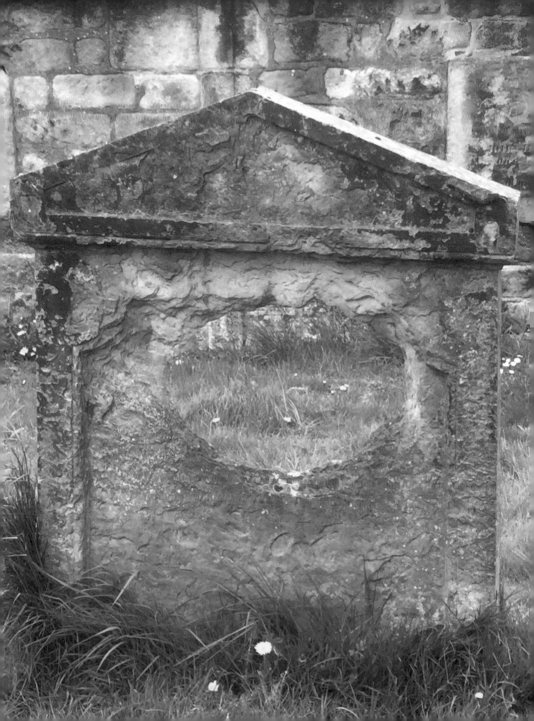

North Berwick
— Bass Rock

Alice arrived in North Berwick by train.
north-berwick.co.uk

Orkney
— Drystone Walls and Ancient Dwellings

The NorthLink Ferries took Alice from
Aberdeen to Kirkwall.
northlinkferries.co.uk
pierartscentre.com
visitscotland.com/destinations-maps/orkney

Westray
— The Redemptive Power of Puffins

Travelling from Kirkwall to Rapness by
Orkney Ferries, Alice took a request bus
to Pierowall where she visited Lady Kirk.
She took a taxi to Castle o'Burrian to
look for puffins.
westraypapawestray.co.uk

Kirkcudbright
— An Artist's Town

Alice took the X74 from Glasgow to Dumfries
and the 502 from Dumfries to Kirkcudbright.
She stayed at The Greengate, and visited The
Stewartry Museum, Broughton House and
The Tolbooth Art Centre.
kirkcudbright.co.uk

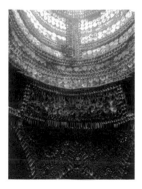

Margate
— Surrounded by Shells

Alice visited The Shell Grotto.
shellgrotto.co.uk

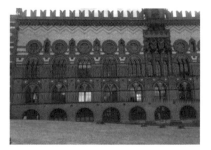

Glasgow
— Women's Hidden Histories

Arriving in Glasgow by Megabus, Alice
followed Glasgow Women's Library's East
End Women's Heritage Walk audio tour.
womenslibrary.org.uk

Oxford
— Finding Calm in Common Ground

Alice walked to Port Meadow via Jericho
from Oxford train station.
oxford.gov.uk/info/20003/parks_and_open_
spaces/823/port_meadow

Cambridge to Ely
— River Cam

Alice walked the Fen Rivers Way, starting
at Cambridge train station, finishing at Ely
train station.
gps-routes.co.uk/routes/home.nsf/
routeslinkswalks/fen-rivers-way-walking-route

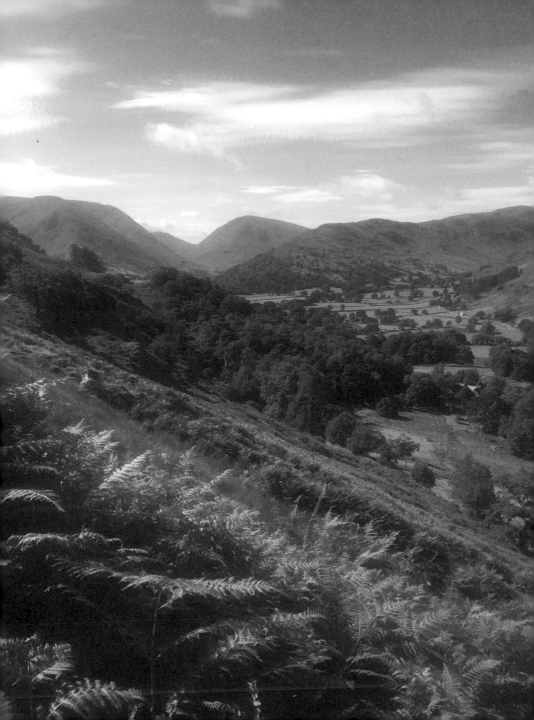

Beaulieu to Buckler's Hard
— Looking for Damerosehay

Taking the train to Brockenhurst, then a car to Beaulieu, Alice joined the riverside walk to Buckler's Hard and back.
www.beaulieuriver.co.uk/about/riverside-walk

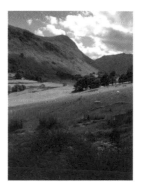

Patterdale
— A Tribute to Topsy

Taking the 508 bus from Penrith train station to Patterdale, Alice stayed at the White Lion Inn and went on various walks: to Lower Hartsop, along Goldrill Beck; over Keldas to Lanty's Tarn; and along Ullswater to Silver Hill.
ullswater.co.uk

Levens Hall
— Living and Breathing History

Alice took the 555 bus from Windermere to Levens Hall.
levenshall.co.uk

Nine Standards Rigg
— The View from the Dinosaur's Back

Nine Standards Rigg is on the Kirkby Stephen to Keld stretch of the Coast to Coast walk, although Alice walked from Nateby via Hartley.
visitcumbria.com/evnp/nine-standards

Kirkby Stephen to Skipton
— The Yorkshire Dales by Train

Alice took the Settle–Carlisle Railway.
settle-carlisle.co.uk

Birmingham to the M5
— A Forgotten Thoroughfare

From Birmingham city centre, Alice followed the Old Main Line and the New Main Line to Sandwell & Dudley train station.
walkingbritain.co.uk/walk-3068-description

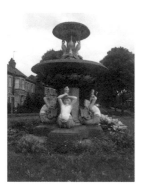

Fringford and Juniper Hill
— A Universe inside a Hamlet

Alice visited the villages of Fringford, Cottisford and Juniper Hill by car.
fringford.info

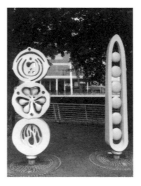

Cardiff
— Decorative Details

Arriving at Cardiff Central train station, Alice walked to Grangetown via Fitzhamon Embankment.
visitcardiff.com

148

Cerne Abbas and Imber
— Village Mysteries

By car, Alice visited Cerne Abbas and Imber villages.
nationaltrust.org.uk/cerne-giant
imbervillage.co.uk

Harlow
— New Town World

Alice followed The Harlow Sculpture Trail and went to The Gibberd Garden.
visitharlow.com/things-to-see--do-/harlow-sculpture-collection/the-collection
thegibberdgarden.co.uk

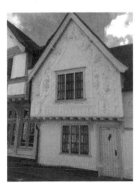

Saffron Walden
— In Praise of Pargeting

In Saffron Walden, Alice went to The Old Sun Inn on Castle Street.
visitsaffronwalden.gov.uk

Stiffkey and Blakeney Point
— Saltmarshes and Seals

First, Alice walked from Stiffkey Marshes to Wells-next-the-Sea. Then she took a boat trip from Morston Quay to Blakeney Point.
nationaltrust.org.uk/blakeney-national-nature-reserve

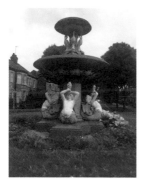

Kingston-upon-Hull
— Saturday Night in the City

Alice went to Ye Olde Black Boy, the
University of Hull Art Collection and walked
to Pearson Park and Newland Avenue.
yeoldeblackboy.weebly.com
www2.hull.ac.uk/fass/arts.aspx
ywt.org.uk/pearson-park-wildlife-garden

Spurn Head Spit
— Extreme Geography

A walk from Kilnsea to Spurn Point and back.
ywt.org.uk/reserves/spurn-nature-reserve

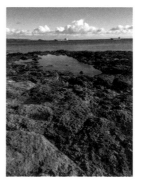

Sunderland
— Histories in Pottery and Glass

Alice visited the Sunderland Museum and
the National Glass Centre.
seeitdoitsunderland.co.uk/sunderland-
museum-winter-gardens
nationalglasscentre.com

Plymouth
— An Abstract City

Cremyll Ferry from Admirals Hard to Cremyll,
Cornwall, then a circular walk around the
Rame Peninsula, walking back along part of the
South West Coast Path.
cremyll-ferry.co.uk
southwestcoastpath.org.uk/walksdb/31

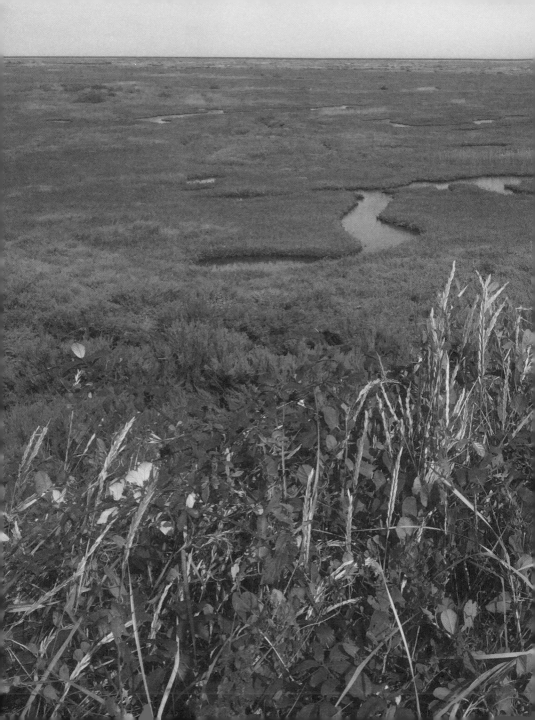

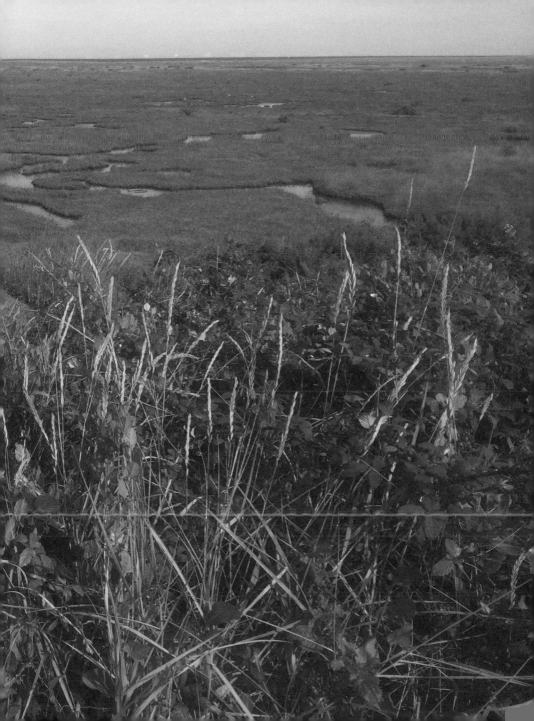

GOOD THINGS FROM A YEAR
OF BRITISH TRAVELS

ARCHITECTURAL ODDITIES AND FOLLIES

Duke's Bath House, Buckler's Hard
Gothic Cottage at Stourhead
Harlow
Mix of architectural styles at Port Sunlight
Old Sun Inn, Saffron Walden
Ruins of the Old Castle, Castle Crom
Shoreham houseboats
The Grotto, Portmeirion

BEACHCOMBERS' DELIGHT

Dungeness
Kirkcudbright
Norfolk Saltmarshes
North Berwick
Orkney
Portmeirion
Southend-on-Sea
Spurn Point Head
Westray

CHURCHES

Christ Church, Port Sunlight
Liverpool Metropolitan Cathedral
St Giles, Imber
St Magnus Cathedral, Kirkwall
St Mary de Haura, New Shoreham
St Mary the Virgin, Cottisford
St Paul's, Harlow
Sikh Gurdwara, Cardiff

CHURCHYARDS

Lady Kirk, Westray
Old Calton Burial Ground, Glasgow
St Cuthbert's Old Churchyard, Kirkcudbright

St Mary & St Julian, Maker
St Patrick's, Patterdale
St Sepulchre's Cemetery, Oxford
Warbeth Cemetery, Orkney

CITY PARKS

Glasgow Green
Harlow Town Park
Midsummer Common, Cambridge
Pearson Park, Hull
Port Meadow, Oxford

COASTAL WALKS

Circular walk on Mount Edgecumbe on the
 Rame Peninsula
Dungeness, a circular walk from the Pilot Inn
 via Dungeness Power Station and Derek
 Jarman's house, Prospect Cottage
Orkney, Stromness to Warbeth;
 Brough of Birsay
Southend-on-Sea to Leigh-on-Sea
Spurn Head Spit, from Kilnsea to Spurn
 Point and back
Stiffkey Saltmarshes, from Stiffkey to
 Wells-next-the-Sea
Westray, around the cliffs at Castle o'Burrian

DAY TRIPS BY TRAIN FROM LONDON

Birmingham
Cardiff
Erith
Harlow
Kennet and Avon Canal, Bath
Margate
Port Meadow
River Cam

Saffron Walden
Shoreham-by-Sea
Southend-on-Sea

DECORATIVE DELIGHTS

Crown Bar, Belfast
Graffiti and street art, Birmingham
Ironwork on Hercules Hall, Portmeirion
Oriental collection in the Lady Lever Gallery,
 Port Sunlight
Pargeting in Saffron Walden and Halesworth,
 Suffolk
Philharmonic Dining Rooms, Liverpool
Porch tiles, Grangetown, Cardiff
Shell Grotto, Margate
Templeton Carpet Factory, Glasgow

DERELICT LANDSCAPES

Bank of Ireland Building, Belfast
Birmingham Canal Navigations
Dingle's boarded-up terraced houses
Dungeness
Erith
Imber village
Orkney: the Second World War bunker
 on Warbeth Beach
Spurn Head Spit

DRYSTONE WALLS

East Riding
Hartley Fell
Kirkcudbright
Orkney
Patterdale
Westray
Yorkshire Dales

GARDENS

Bridge End Garden, Saffron Walden
Cerne Abbey gardens, Cerne Abbas
Derek Jarman Garden, Prospect Cottage,
 Dungeness

Garden at The Greengate, Kirkcudbright
Levens Hall, Cumbria
Mount Edgecumbe Country Park, Plymouth
Portmeirion, North Wales
Royal Botanic Garden, Edinburgh
Stourhead Garden, Wiltshire
Water Gardens, Harlow
Winter Gardens, Sunderland

GUIDED TOURS

Magical Mystery Tour, Liverpool
Sculpture Trail, Harlow
Seal trips, Blakeney
Spurn Safari
Women's Heritage Walks audio tour,
 Glasgow

JOURNEYS ON LOCAL TRANSPORT

502 bus, Dumfries to Kirkcudbright
508, Penrith to Patterdale
Bus X1, Orkney to Stromness
Coasthopper, North Norfolk
Ffestiniog Railway, Snowdonia
NorthLink Ferries, Aberdeen to Kirkwall
Settle–Carlisle Railway
Westray Bus Service

LIGHTHOUSES

Bass Rock Lighthouse, off North Berwick
Brough of Birsay Lighthouse, Orkney
Portmeirion Lighthouse
Roker Lighthouse, Sunderland
Samuel Wyatt's Tower, the High Light Tower,
 Dungeness Lighthouse, Dungeness
Smeaton's Tower, Plymouth
Spurn Lighthouse

MUSEUMS AND LIBRARIES

Glasgow Women's Library
Maritime Museum, Hull
Orkney Library, Kirkwall

People's Palace, Glasgow
Saffron Walden Museum
Stewartry Museum, Kirkcudbright
Sunderland Museum

MYSTERIES

Giant and well, Cerne Abbas
Imber village
Nine Standards, Kirkby Stephen
Saracen Head pub, Glasgow
Shell Grotto, Margate

NICE NEON

Barrowland Ballroom, Glasgow
Chinatown, Manchester
Lower Morden Lane, Morden
Margate
Southend-on-Sea

PUBLIC ART

Cardiff (see the Cardiff Public Art Register,
 but also look out for the small design
 details that can be found everywhere)
Harlow Sculpture Trail
Street art, Birmingham
Templeton Memorial Garden
Underpass mural, Sunderland
William Mitchell murals, Liverpool

PUBS

Bath Arms at Longleat, Hornisham
Belvedere Arms, Sugnall Street, Liverpool
Crooked Billet, Old Leigh, Leigh-on-Sea
Old Bookbinders, Victor Street, Oxford
Orkney Brewery, Cawdor, Orkney
Penny Farthing, Waterside, Crayford
Perch, Binsey Lane, Oxford
Philharmonic Dining Rooms, Hope Street,
 Liverpool
Red Lion, Wells Road, Stiffkey
Rising Sun, Cawsand
Spread Eagle Inn, Church Lawn, Stourton

White Lion, Patterdale
Ye Olde Black Boy, High Street, Hull

REGIONAL ART GALLERIES

Fry Art Gallery, Saffron Walden
Kirkcudbright Art Gallery (it hadn't
 opened when I visited, but I know
 it is going to be a favourite)
Lady Lever Art Gallery, Port Sunlight
National Glass Centre, Sunderland
Pier Arts Centre, Stromness, Orkney
The Whitworth, Manchester
University of Hull Art Collection

RUINS AND ANCIENT SITES

Broch of Borwick, Orkney
Brough of Birsay, Orkney
Cerne Abbey, Cerne Abbas
Lady Kirk, Westray
Nine Standards, Kirkby Stephen
Old Castle, Castle Crom
Parts of St Peter's, Monkwearmouth
Ring of Brodgar, Orkney
Skara Brae, Orkney

SEASIDE TOWNS

Cawsand and Kingsand
Kirkwall
Leigh-on-Sea
Margate
North Berwick
Portmeirion
Shoreham-by-Sea
Southend-on-Sea
Stromness
Wells-next-the-Sea

SPECTACULAR VIEWS

Across the marshes from the coastal
 path at Stiffkey
At Tanygrisiau, walking up towards
 Llyn Stwlan

Cerne Abbas Giant from the viewing point
From the train between Minffordd and
　　Tanygrisiau
Glenariff: the glens on the walk back to the
　　visitor centre on the Waterfall Walk
Looking across at Plymouth Sound from
　　the Rame Peninsula
Orkney, the Giant of Hoy from
　　Warbeth Beach
Patterdale, the scene over Ullswater
　　from Silver Hall
Portmeirion, the viewing point at
　　The Clifftop and The Grotto
Spurn Head Spit
360-degree panorama at Nine
　　Standards Rigg
View from the top of North Berwick Law

TREES AND WOODLAND

Beaulieu
Glenariff
Great Bradley Wood
Patterdale
River Cam
Stourhead
Topiary at Levens Hall
Yew trees, Castle Crom

URBAN NEIGHBOURHOODS

(By and large, in my opinion, city
　　centres are horrid)
Grangetown, Cardiff
Hope Street Quarter, Liverpool
Inverleith, Edinburgh
Jericho, Oxford
Queen's Park, Glasgow
The Avenues, Hull

UTOPIAN BRITAIN

Harlow
Liverpool Metropolitan Cathedral
Margate

Plymouth
Port Sunlight
Portmeirion

WATERWAYS

Beaulieu River, New Forest
Kennet and Avon Canal, Bath
Old Main Line and the New Main Line,
　　Birmingham Canal Network
River Cam, Cambridge to Ely
River Thames and River Darent, Erith
River Wear, Sunderland
The Thames, Port Meadow, Oxford
Ullswater, Cumbria
Water of Leith, Edinburgh

WILDLIFE

Dragonflies on the River Cam
Lichen, birds and seals on Orkney
Puffins at Westray
Roe deer at Spurn Point Spit
Seals and thousands of birds at
　　Blakeney Point

ABOUT THE AUTHOR

Alice Stevenson is a London-based illustrator, artist, surface pattern designer and educator. Alice's creative output is informed by her observations of the world around her, using playful compositions and decorative forms to communicate ideas and narratives. She has been commissioned by a wide range of international clients including: Crabtree & Evelyn, Leo Burnett, *Stella* magazine, Kellogg's, Faber & Faber, Waitrose, Volvo, Vodafone, Marc by Marc Jacobs, *Vogue*, Hugo Boss, Tesco, Sainsbury's and St Jude's. Her first book was *Ways to Walk in London*, and from this was created her *London Perspectives Colouring Postcards*.

www.alicestevenson.com

ACKNOWLEDGEMENTS

This book would not exist without the understanding and guidance of Hannah MacDonald and Charlotte Cole at September Publishing, the unique design vision of Claudia Doms and the steadfast support of my agent Becky Thomas.

I am grateful to everyone who joined me on my travels, chauffeured me around and hosted me: Alice Maddicott, Ross Beard, Jonathan Portlock, Roger Dean, Peter James Field, Elinor Cook, Adam Winter, David Potter, Geoff Blunt, Nick Ballon, Alma Haser, Guy Lawrence, Amee D'Souza, Odin D'Souza, Kati Kärki, Katie Gordon, Caroline Stevenson, Charlotte Cole, Edward Stevenson, Joseph Stevenson, Stephanie Stevenson, Alex Loy, James Deeley, Holly Wales, Stephen Smith, Tom Dougherty and Kim Horrocks.

Thank you to Ross Beard, without whose love and support I could never have pulled this off.